Seneca Ray Stoddard

Seneca Ray Stoddard

Transforming the Adirondack Wilderness in Text and Image

Jeffrey L. Horrell

Syracuse University Press

LIBRARY OF CONGRESS CATALOGING-IN-PUBLICATION DATA

Horrell, Jeffrey L., 1952–
 Seneca Ray Stoddard : transforming the Adirondack wilderness in
text and image / Jeffrey L. Horrell. — 1st ed.
 p. cm.
 Includes bibliographical references (p.).
 ISBN 0-8156-0609-5 (cloth : alk. paper)
 1. Nature photography—New York (State)—Adirondack Mountains.
 2. Wildlife photography—New York (State)—Adirondack Mountains.
 3. Stoddard, Seneca Ray, 1844–1917. I. Title.
 TR721.H65 1999
 508.747′5—dc21 99-38355

Book design by Christopher Kuntze
Manufactured in the United States of America

To the memory of my father

C. WILLIAM HORRELL

photographer and teacher

Jeffrey L. Horrell is Associate Librarian of Harvard College for Collections, Cambridge, Massachusetts. His research interests include academic librarianship and the history of photography. He has published in *Art Documentation* and *The Magazine Antiques*.

Contents

Illustrations

Preface

The literary and photographic work of Seneca Ray Stoddard has not been the subject of scholarly study until recent decades. Stoddard's career is grounded in the realm of popular culture of the Adirondacks in the middle to late nineteenth century, and art photography as an important medium of artistic expression has, in the main, excluded ostensibly "commercial" work. For that reason, the work of Stoddard was virtually ignored. Only in the past two decades has he been acknowledged for the quality of his work, rather than only for its usefulness in historical documentation of the region. Exhibitions at the Adirondack Museum and Syracuse University have been mounted, and a very few, although important, journal articles relating to his work as a photographer have appeared. A book on Stoddard's life, published in the early 1970s, presented a broad but sketchy overview of his career with anecdotes concerning him, but it was not intended to be scholarly or comprehensive, as evidenced by a lack of a bibliography or footnotes. A recent monographic work on Stoddard is devoted to his photographic production. Nothing of substance has been published about Stoddard as a writer.

This book will explore how Stoddard's texts and images reflected the changing perceptions of wilderness in the Adirondacks in the nineteenth century. By constructing a detailed description of the corpus of Stoddard's work reflecting the theme of wilderness and the emerging tourist industry in the region, his important and lasting contributions to the understanding of the transformation of impressions of the Adirondacks will be evident.

During the course of researching and writing this book (based on my 1995 Syracuse University dissertation), I have accumulated many intellectual debts that I must acknowledge. I wish to thank

the staffs of the Arents Library of Syracuse University, the Print and Photograph Division of the Library of Congress, and the Photograph Departments of the Art Institute of Chicago and the J. Paul Getty Museum. In particular, I am grateful for the generous assistance of the following people: Jerold Pepper, librarian, and Jim Meehan, manager of Historical Photographs and Films, at The Adirondack Museum; Beth Shepherd, former curator, and Rebecca Gereau, current curator of the Chapman Museum; Rachel Stuhlman, librarian of the International Museum of Photography at George Eastman House, Ann Abid, librarian of the Cleveland Museum of Art, and Deirdre Lawrence, librarian of the Brooklyn Museum. I am grateful for the fine editorial guidance provided by Jaylyn Olivo.

Warm thanks to Margie May, secretary of the Humanities Doctoral Program at Syracuse University, who has been endlessly helpful and kind. I also wish to thank Dr. David Stam, who persistently encouraged me to pursue further graduate work and afforded me the opportunity to do so while working under his leadership as librarian at Syracuse University. Professor Mary Lou Marien, through her inspired teaching and personal guidance, has informed how I look at images. Professor Frank Macomber has been an ongoing source of encouragement, good humor, technical support, and wise counsel. I thank Professor Emerita Antje Lemke for her support from a very early stage in my professional career. Professor David Tatham has overseen my study and research. I am most grateful for his critical insights, clarity, fine editorial suggestions, and patience. This effort would not have been realized without his guidance and encouragement.

I wish to thank the trusees of the Gladys Krieble Delmas Foundation for a generous grant to support the production of the illustrations for the book.

And special thanks to Rodney Rose for his encouragement throughout this project.

Cambridge, Massachussetts *Jeffrey L. Horrell*
June 1999

Introduction

The life and career of Seneca Ray Stoddard (1843–1917) spans the early development of the photographic medium and parallels the "discovery," exploration, and exploitation of the Adirondack region of New York State as an area of great scenic beauty. During his lifetime the region attracted artists, tourists, and summer residents in steadily increasing numbers. Throughout this time, perceptions of the American wilderness in the Adirondacks and elsewhere changed from negative to generally positive. Many factors influenced this change, among them the rise of photography. Although Stoddard was primarily a photographer, he was also a writer, publisher, and entrepreneur and occasionally a graphic artist.

In the first sentence of *Nature and the American*, Hans Huth states that "man's love of nature is now taken for granted" (Huth 1957, 1). This attitude was not necessarily the case from the earliest settlement of America through the first years of the nineteenth century. In fact, there was a long tradition of negativity in Western thought and legend toward nature in general and wilderness in particular. In America, the early settlers rejected much that was not of immediate and practical use. The axe was an early accepted symbol of the common attitude toward nature. This is not to say that travelers ignored scenic beauty, but that beauty and bounty were rarely ends in themselves in western expansion. Through the course of nineteenth-century scientific exploration, philosophers of nature and others developed attitudes toward the natural environment that marked a transition to more positive ideas in popular thought about wilderness. The romantic visions of writers, artists, and, subsequently, photographers helped to create a reverence for wild nature. Photography documented the landscape well

before many travelers, and eventually settlers, saw it. Photographs influenced the expectations of those who saw them and shaped the ways in which individuals saw and thought about the world around them.

My purpose in writing this book is to provide an understanding of Stoddard's work, both photographic and literary, and of how it influenced and was influenced by the changing attitudes toward, and perceptions of, wilderness in the second half of the nineteenth century in the Adirondacks. A physical description and history of the region will be useful at the outset, as will a summary of the perceptions of wilderness up to the nineteenth century in Western thought. The first chapter also describes the traditions in which Stoddard began his career, and the development of the tourist industry that sustained it.

Stoddard spent most of his working life writing about and illustrating the Adirondacks. Beginning as a sign painter in Glens Falls, New York, he took up photography in the mid-1860s. He combined his skill as a photographer, his ability as a draughtsman, and his engaging writing style to produce illustrated guidebooks for the growing tourist trade in the early 1870s. Successive revised editions appeared from his hand for a few decades, the last appearing in 1914. Although there had been a well-established tradition of guidebooks for American tourist regions, the inclusion of illustrations based on photographs, which was Stoddard's practice, represented a new departure. His text and illustrations reflected not the views of a visitor, as did most guidebooks, but those of an "insider," someone who approached the subject with a long-standing and intimate knowledge of the region.

Stoddard included photographs in a variety of entrepreneurial ventures geared toward expanding the tourist trade of the Adirondacks. His books progressively reflected changes in modes of transportation from steamships to the railroad and eventually to the automobile. In 1892 he addressed the New York State Assembly in support of the proposal to create an Adirondack Park and promoted the concept in an illustrated lecture throughout the state.

Introduction

In this book I explore the nature of the influence Stoddard exerted on perceptions of the region and on the perception of wilderness in general. I will consider the extent to which Stoddard led or followed (or both) in changing these perceptions and will attempt to show how his work reflected matters of class and power on the emerging tourist industry in the Adirondacks. I address related questions as well: Are Stoddard's images art photographs or only illustrations to a text? What influence did he have on the popular literature of the period, and vice versa? To what degree was Stoddard a travel writer or simply a compiler of guidebooks? I will discuss these questions within the context of the images, texts, and promotional matter that Stoddard produced throughout his long career.

Abbreviations

Page references to works by Seneca Ray Stoddard are cited with the following abbreviations. A complete list of Stoddard's written works follows the text.

AI *The Adirondacks, Illustrated*

AI 89 *The Airondacks Illustrated 1889*

Ego *Egoland, An Illustrated Magazine of Travel, Truth and Fiction*

HH "The Head-Waters of the Hudson"

LAP "Landscape and Architectural Photography"

LGI *Lake George; Illustrated*

PA "Pictured Adirondacks"

PT *Picturesque Trips Through the Adirondacks in an Automobile*

Sag *Sagamore 1899*

SNM *Stoddard's Northern Monthly*

TA *The Adirondacks*

Seneca Ray Stoddard

1 The Adirondacks and the Concept of Wilderness in the Nineteenth Century

The Adirondacks Before Tourists

The Adirondacks have attracted a variety of individuals—loggers and conservationists, rich and poor, hunters and fishermen, painters, writers, and photographers—all in search of sanctuary of one sort or another. The Adirondack region is one of contrasts, paradoxes, and inconsistencies. Its inhabitants have loved, exploited, cared for, and argued over the land in ways few places have experienced (Keller 1980, x–xi).

The very earliest history of the Adirondacks began some three-and-one-half billion years ago, making them among the world's oldest mountains; the Alps, Andes, Rockies, and Himalayas are considerably younger. The primary geological composition of the Adirondacks is anthracite, feldspar, and granite. It is believed that successive shifts in the earth's crust reduced their height from twelve miles above sea level to an approximate elevation of six miles, and millions of years of erosion, including a succession of ice caps, have brought them to their present much lower height (Weston 1971, 22).

Geologically, the Adirondacks were originally part of the Canadian Laurentians, covered by Grenville geosyncline (Carson 1928, 1–2). A glacial upheaval formed the Appalachian chain, with the northern end rising first and then creating the Hudson Highlands, the Blue Ridge, and the Great Smokies. The Green and White Mountains of Vermont and New Hampshire eventually eroded to a lesser degree than the Adirondacks (Weston 1971, 22).

An extensive discussion of the origin of the name "Adiron-dacks" is found in Carson's *Peaks and People of the Adirondacks* (1928, 7–13). Carson traces the popular use of the name to Charles Fenno Hoffman, who published *Wild Scenes in the Forest and Prairie* in 1839 in London, followed by an American edition four years later. Hoffman writes in the first edition: "The group of hills among which the Hudson arises stand wholly detached from any other range in North America. The highest peak of the Aganus-chion range, or the Black Mountains, as some call them, from the dark aspect which their sombre cedars and frowning cliffs give them at a distance, was measured last summer to be nearly six thousand feet in height" (Carson 1928, 7). In the American edition of 1843, the name "Adirondacks" appears in the quotation in place of "Aganuschion." In actuality, the mountain (Marcy) was discov-ered in 1837 by Professor Ebenezer Emmons and measured 5,344 feet.

The Iroquois referred to the Algonquins as "Adi-ron-dacks," which meant "bark-eaters," because the Algonquins subsisted on roots and tree bark during hard winters (Weston 1971, 25). Other names, such as the "Peruvian Mountains," "Mountains of St. Marthe," and "Corlear's Mountains," have been cited, the former two derived from French attributions and the latter from an Indian adaptation of a Dutch name. These represented nationalities with strong interests in the region. However, it was Ebenezer Emmons who established the name Adirondacks for the region. Emmons was commissioned in 1836 to survey the Adirondacks and report to the New York State Legislature. In the following year, he led an expedition up the highest peak in the region and subsequently named it Mount Marcy. His party included several other scientists and Charles Cromwell Ingham, an artist who was one of the founders of the National Academy of Design (Graham 1978, 12). In 1838, the entire mountain range was named the Adirondacks. Em-mons's explanation of the name is as follows:

> The cluster of mountains in the neighbourhood of the Upper Hud-son and Ausable rivers, I propose to call the Adirondack Group, a

name by which a well-known tribe of Indians who once hunted here may be commemorated.

It appears from historical records that the Adirondacks or Algonquins in early times held all the country north of the Mohawk, west of Champlain, south of Lower Canada, and east of the St. Lawrence River, as their beaver-hunting grounds, but were finally expelled by the superior force of the Agoneseah, or Five Nations. Whether this is literally true or not, it is well known that the Adirondacks resided in and occupied a part of this northern section of the state, and undoubtedly used a portion at least of the territory thus bounded as their beaver-hunting grounds. This name is not as smooth as Aganuschioni, which has been also proposed as a name for the group, but given the historical fact has induced me to propose the one given above. (Carson 1928, 9)

With Emmons's report and his use of the name, the numerous other names faded from use. Emmons included an artist on his expedition to record the topology and scenery. This task would later be performed by the camera. We will return to Ingham in the section on the artists of the Adirondacks in the nineteenth century.

The earliest account of the Adirondacks by a non-native was that of the French explorer Jacques Cartier, who on October 2, 1536, arrived at the Indian village that eventually became the site of Montreal (White 1985, 3–4). From that location, on a clear day, Cartier could have seen the Adirondacks approximately seventy miles to the south.

The individual often credited with discovering the Adirondacks nearly three generations later is Samuel de Champlain. In 1608, on his third expedition to North America, Champlain founded the settlement of Quebec. The following July, Champlain, along with a small group of Europeans and Algonquin Indians, traveled down the Sorel River to the lake that in time was to be named after the explorer. The expedition encountered a tribe of Iroquois, and shots fired by Champlain and his followers changed the course of history and of the region. The Iroquois retreated and forever after hated the French, as they did the Algonquins (Donaldson 1921, 1:8–9). In his narrative account, Champlain describes seeing, from a certain

point on the lake, mountains to the east and the south. To the east were most likely the Green Mountains of Vermont and to the south some part of the Adirondacks. By coincidence, several months later, Henry Hudson sailed up what would be called the Hudson River to just above Albany, where he probably saw the foothills of the Adirondacks. Two important explorers saw the outer edges of the region from different vantage points within a very short period of time (Kaiser 1982, 15).

Subsequently, Jesuit missionaries introduced white men to the Indian lands. In the course of a century or so, beginning in 1657, at least twenty-four missionaries went among the Iroquois. Simultaneously, the periphery of the region was being exploited by French, Dutch, and Indian trappers for an ever-expanding fur market in Europe. The French in the north and the English in the south fought repeatedly before reaching a resolution in 1759 over the valuable fur trade of the Lake Champlain–Lake George region of the eastern Adirondacks (Kaiser 1982, 15).

During the same period, large tracts of land were acquired by Sir William Johnson in and around the Mohawk Valley. Speculation in land was common in the upper Hudson and Champlain area. A tract of land covering much of Essex, Warren, Hamilton, and Herkimer counties became known as the Totten and Crossfield Purchase. Its northern boundary extended from Keene Valley to the west and south of Cranberry Lake and included Raquette Lake, Blue Mountain Lake, Indian Lake, Pleasant Lake and others. The tract, originally estimated at 800,000 acres, was in fact about 1,115,000 acres. The name Totten and Crossfield Purchase was in fact a misnomer, as neither Joseph Totten nor Stephen Crossfield, both ship carpenters in New York City, was the intended purchaser, but they were "front men" for wealthy and powerful Manhattanites who wanted their identities concealed. This technique was commonly used to prevent political enemies from blocking important deals. Furthermore, the Totten and Crossfield purchase was never completed. Because unclaimed land belonged to the Indians, white men were required to make deals with Indians, but

the English Crown ruled that Indian title first had to pass to the Crown and then to others, thereby giving the Crown the opportunity to collect taxes on it. As the purchase was moving forward and survey work began for eventual subdivision, the American Revolution began, and the entire tract reverted to the state of New York (Masten 1923, 3–9).

From the end of the American Revolution to the turn of the nineteenth century, states such as New York with much unclaimed land competed vigorously for settlers. It was generally believed desirable to have the land in private ownership so that the British in Canada could not claim it. In 1792, Alexander Macomb purchased nearly four million acres at sixteen cents an acre. The considerable controversy regarding the transaction included accusations of fraud and collusion at high levels in the United States government. The result of this purchase and the Totten and Crossfield Purchase was that most of the land in the Adirondacks was privately owned. In time, most of it returned to state ownership in lieu of unpaid taxes (White 1985, 70–74).

Over the next several decades, isolated settlers made their homes and livelihoods in the interior of the Adirondacks. Some cleared land, sold it, and then moved on to repeat the process. Others were trappers and some were "professional" hermits; both became part of the lore of the region. With the introduction in the second half of the nineteenth century of coach lines and subsequently of steamboat and rail travel, the landscape and culture of the Adirondacks continued to be transformed.

The period between the finishing of Emmons's survey work of the 1830s to the conclusion of the American Civil War in 1865 is often referred to as the era of "golden years" of the Adirondacks (Kaiser 1982, 21). During this period the public first became aware of the Adirondacks, and the wilderness gradually opened to travel and sport. Developments in transportation allowed the lumber industry to prosper and enticed tourists to explore. A literary and artistic tradition arose to parallel the changes occurring in the commercial sector.

As early as 1834, plans were made for introducing rail trans-portation to the Adirondacks, although little came from them at first. The initial venture, developed by the Manheim and Salisbury Railroad Company (named for two towns in the Mohawk Valley), was to connect Little Falls via Long Lake with the Raquette River. The plan never materialized (Hochschild 1962a, 1–4). Other at-tempts included the Sackett's Harbor and Saratoga Railroad Com-pany, which became the Lake Ontario and Hudson River Railroad Company. It proposed a line from Saratoga to Sackett's Harbor on Lake Ontario but failed owing to the onset of the Civil War.

In the mid-1860s, Thomas C. Durant, formerly a surgeon, took over the bankrupt Adirondack Railroad and formed the Adiron-dack Company. It took nearly six years to complete the sixty-mile stretch of track from Saratoga to North Creek. Only one passenger train and an occasional freight train ran on this route. An editorial in the *New York Times* on August 9, 1864, entitled "A Central Park for the World," stated that with the completion of the line be-tween Saratoga and either Lake Ontario or the St. Lawrence, "the Adirondacks region will become a suburb of New York." With finances exhausted, Durant discontinued expansion beyond North Creek, a project that did not resume until the 1940s. The history of Adirondack railroads in the nineteenth century was one of be-ginnings and failures. The difficulty of the terrain and the scant population of the region militated against success in most cases.

A number of railway projects finally managed to piece together small portions of the region, notably the Chateaugay Railroad from Plattsburg to Saranac Lake and the Saranac Lake and Lake Placid Road, but the Adirondack and St. Lawrence Railroad was the first to create a significant through line, a connection between New York and Montreal running along the eastern margin of the region. Dr. William Seward Webb, the son-in-law of William H. Vanderbilt, attempted to interest the New York Central Railroad in the project, but without success. Webb then decided to build it himself. After being denied the right-of-way from the state, he persevered and purchased the land. Within eighteen months, on

July 1, 1892, the railroad was operating. What was thought of as "Webb's Golden Chariot Route" to his own land was purchased the next year by the New York Central Railroad (Donaldson 1921, 2:131–41).

With the introduction of rail transportation, both Durant and Webb made access to the region easier and faster than it had been by stagecoach, guideboat, or foot. The railroad was critical to the mining and lumber industries, and it also had an impact on the emerging tourist industry. It is important to examine its impact on mining and lumber as background for the changes that writers, artists, and then tourists would bring to the Adirondacks.

Several industries, aside from tourism, left their mark on the Adirondacks. The mining of iron ore was a difficult and hazardous business, but more than two hundred iron mines and forges operated in the region during the nineteenth century. Serious mining operations began in 1804. Some iron ore was unearthed from open pits, but much of it had to be tunneled out from below the earth's surface. After being brought to the surface, the ore was loaded on horse-drawn wagons, carried to cargo boats, and shipped to furnaces all along the eastern seaboard. In good years, early in the nineteenth century, a quarter-million tons of ore were excavated. By 1905, roughly thirteen million tons had been removed from the region (Donaldson 1921, 1:136–49). The industry eventually dwindled as impurities in the ore made it uncompetitive with purer ore from other regions (Masten 1923, 149). One impurity turned out to be titanium, which in time became a valuable commodity and which is still mined for use in producing metal alloys. The mining industry in the Adirondacks shrank to but a fraction of its early-nineteenth-century size before the end of the century. Mining towns became tourist curiosities.

Another industry, in some ways more important, was lumber. Nearly every accessible valley and mountainside of the Adirondack region was cut sometime in the nineteenth century (Holt and Garey 1987). The largest lumber operations were located close to the major rivers, the Hudson, the Raquette, and the Saranac. Lum-

bering on the Upper Hudson and its tributaries began in 1813 and continued for the next three-quarters of a century (Donaldson 1921, 2:150–62). Early logging depended on waterways to move the timber to the mills. Logs were marked with the brands of individual owners, similar to cattle branding, then floated down the river to the mill for cutting. Logging was a difficult business. Log jams in icy waters had to be broken up by hand. At first, only soft wood was cut and transported by water, because hardwood was too heavy to float. Later, improved roads and railroads made transporting hardwood feasible. By the 1830s, Glens Falls, on the Hudson, was the most important lumber center of the region. Glens Falls was the "Big Boom," the place where logs from various rivers in the Adirondacks were held for future sawing (McMartin 1994, 60). The rivers and streams flowing into the Hudson became virtual highways for logs. By midcentury the industry reached the center of the Adirondacks. Nearly a half-million trees were cut each year, producing more than a billion board feet of lumber. One subsidiary industry evolved from lumbering: the bark of hemlock trees served to tan animal hides. This tanning process was used well through the nineteenth century until other easier and less expensive processes were developed (White 1985, 91–92). Over the course of the thirty to forty years after 1850, great portions of the Adirondack landscape were clear cut, leaving only stumps and barren mountainsides. Conflict between exploitation and preservation of the land arose early, but a widespread early view was signaled in the optimistic 1864 editorial in the *New York Times*, mentioned earlier, that stated:

> The furnaces of our capitalists will line its valleys and create new fortunes to swell the aggregate of our wealth, while the hunting lodges of our citizens will adorn its most remote mountain sides and the wooded islands of its delightful lakes. . . .
>
> In spite of all the din and dust of furnaces and foundries, the Adirondacks, thus husbanded, will furnish abundant seclusion for all time to come and will admirably realize the true vision which should always exist between utility and enjoyment.

Adirondacks and the Concept of Wilderness

By the 1870s, New York State paper mills, with two-thirds of their lumber coming from the Adirondacks, were the largest producer of paper in the country. Wary of uncontrolled cutting, in 1872 New York State established the Commission of State Parks to oversee state-owned timber lands. As land values increased in proportion to the growing scarcity of timber, stealing from state lands also increased. The debris left after the cutting created additional problems. Fires were ignited by the heat of locomotives as well as by farmers clearing their land. Approximately one hundred and fifty thousand acres of timber burned in 1880, attributed to these and related causes.

In 1885, with considerable public pressure (much of it coming from outside the region), New York State established a Forest Preserve to oversee everything from replanting efforts to enforcement of the requirement that railroads place screens over the stacks of locomotives. It also developed a system for reimbursing counties for tax revenue losses for public (and unusable) land. The state-owned forest preserve lands seemed safe, but the 1885 law did not address the selling or leasing of, and removal of trees on, forest lands. It did not take long for lumbermen and entrepreneurs to discover these omissions. In 1892 the Adirondack Park was established, again after considerable lobbying. (Seneca Ray Stoddard's presentation on this subject before the New York State Legislature is discussed in chap. 2.) Because the 1892 bill did not affect private property, and did not provide specifics regarding land use, it was more symbolic than restrictive. A constitutional convention two years later provided an amendment with wording that protected the forest lands from destruction. The legislation "locked up" the Adirondacks and made tourism the region's primary industry from that point forward (White 1985, 212–20).

Evolution of the Concept of Wilderness

As changes occurred in the Adirondack region, so too did a transformation of thought occur regarding the physical landscape.

These changes evolved from a long tradition in Western thought. With the rise of civilizations, wilderness was thought of as something alien to humans—"an insecure and uncomfortable environment against which civilization had waged an unceasing struggle" (Nash 1967, 8). Wilderness had traditionally been the antithesis of the civilized ideal world.

Roderick Nash describes this ideal world:

> The value system of primitive man was structured in terms of survival. He appreciated what contributed to his well-being and feared what he could not control or understand. The "best" trees produced food or shelter while "good" land was flat, fertile, and well watered. Under the most desirable of all conditions the living was easy and secure because nature was ordered in the interests of man. Almost all early cultures had such a conception of an early paradise. No matter where they were thought to be or what they were called, all paradises had in common a bountiful and beneficent natural setting in accord with the original meaning of the word in Persian—luxurious garden. A mild climate constantly prevailed. Ripe fruit drooped from every bough, and there were no thorns to prick reaching hands. The animals in paradise lived in harmony with man. Fear as well as want disappeared in the ideal state of nature. (Nash 1967, 8–9)[1]

With paradise as the ideal state, wilderness was considered a state of evil. In Christian belief, the ideal world was Heaven; the real world of civilized existence was intrinsically inferior, and the "unimproved" world was worse still. Seeking a life without wilderness, humans attempted to overcome nature through the use of fire, the domestication of animals, the clearing of land, and the raising of crops.

Greek and Roman traditions glorified ordered nature for its usefulness. In contrast, classical mythology associated wilderness with the supernatural. Mystery surrounded wilderness, particularly at night. Forests took on an animated life with fearful connotations (Taylor 1873, 2:214–29). Greeks traveling through the

1. Nash cites the work of Mircea Eliade (1959); Loren Baritz (1961); Arthur O. Lovejoy and George Boas (1935); and George Boas (1948).

forest feared encounters with Pan, the god of the woods. The word "panic" originated from the fear travelers felt when they thought they were about to approach the deity (Nash 1967, 11). Related to Pan in appearance were tribes of satyrs, goatlike men who devoted themselves to uncivilized and immoderate indulgence in wine, dancing, and lust. Ruled by wild passion rather than civilized reason, satyrs carried off women and children who ventured into the wilderness.

Judeo-Christian beliefs perpetuated these attitudes toward wilderness. The word wilderness appears 245 times in the Old Testament of the Bible (Revised Standard Version) and thirty-five times in the New Testament. The terms "desert" and "waste," which are thought to have similar significance, appear several hundred times (Ellison 1957). The Hebrews used a number of variations of the term wilderness to create a contrast with the good land that supported crops and herds. Wilderness was God's curse, a penalty for humankind's loss of paradise through expulsion from the Garden of Eden. "Eden" was the Hebrew word for "delight," and the book of Genesis describes it so. When Adam and Eve are punished, they are driven from paradise to the cursed wilderness (Nash 1967, 14–15).

Christianity provided contradictory ideas regarding the concept of wilderness. Wild country offered a refuge from corrupt society. Christian monks and hermits found wilderness a place of solitude where they could contemplate their faith and live in what they believed to be an approximation of moral perfection. The retreat of Saint Anthony to the desert is one of many examples. Monks believed that wilderness could be transformed into paradise.

In contrast to mainstream Western thinking, Eastern religious thought treated the relationship between humankind and nature as parts of a unity. Buddhism, Jainism, and Hinduism viewed humans as a part of nature; to humans wilderness was a symbol of the divine. The ancient Chinese sought in wilderness a clearer understanding of the unity of the universe. In Japan, the Shinto religion combined the concept of God and wilderness; the two

together were objects of worship. Chinese and Japanese landscape painting depicted and glorified the wilderness more than a thousand years before Western artists did so. The Asian artist-philosopher was expected to travel to the wilderness and remain for months to meditate on nature before painting. The eleventh-century Chinese landscape painter Kuo Hsi is reported to have asked why man delights in the landscape and answered that it nourishes his own nature. The purpose of landscape painting was to translate the experience of the knowledge and beauty of nature for those who could not experience it directly. Apart from these traditions, Western thought continued to have a strong bias against wilderness, as was clearly demonstrated by those exploring and settling the New World.

In 1831, during his trip to America, Alexis de Tocqueville surprised the settlers in the Michigan Territory with a request to travel to wilderness areas for the pleasure of it. It was difficult to convince them that his interest was in neither lumbering nor land speculation. He was intrigued that Americans had so little interest in wilderness compared to that of Europeans. According to Nash, American pioneers held a bias against wilderness. On a physical level, the vast American wilderness presented a very real threat to survival. For the earliest settlers, the wilderness meant wild people (Indians), beasts, and a generally hostile environment. J. Hector St. John Crevecoeur, in the late eighteenth century, described Indian attacks, with the wilderness contributing to the distressful situation (Crevecoeur 1782, 272). In general, though, Crevecoeur was optimistic about the American wilderness (Burns 1989, 4). Encounters with wild and dangerous animals in the wilderness became a staple of American folklore. In addition to wild men and beasts, the idea of the settlers themselves behaving in savage ways also developed. Many were fleeing oppressive European laws and customs, and complete freedom in the wilds of a new land was a powerful temptation to live by "nature." Crevecoeur and others argued that happiness was not achieved by living in solitude, but in communal environments bound by social con-

ventions and order (Crevecoeur 1782, 55–57, 271). The wilderness symbolized a cursed and chaotic wasteland. Its settlers fought to survive in the name of God, race, and national identity, but they also had a fair chance, once they subdued the wilderness and exploited the land, to prosper. In the general westward expansion, wilderness was viewed as the villain, the pioneers as heros, and the conquest of wilderness as victory (Nash 1967, 24–25).

In New England, the Puritans saw themselves as conquering the wilderness to advance God's cause. The Old Testament portrayed the desert as the cursed land, and so, too, early New Englanders in their writing described the wilderness as an "environment of evil." The Puritans argued that the devil had seduced the Indians; they were therefore not simply savages but acted for intrinsically evil purposes. The wilderness was not just a physical obstacle, it contributed to the circumstances of evil. The colonists considered themselves soldiers in Christ's army in a war against wildness (Nash 1967, 36–37). The Puritans may even have accentuated the hardships and the temptations of the wilderness so that future generations would be reminded of their accomplishments in overcoming these things. Although most of the credit went to God, the Puritans themselves took much pride in overcoming the wilderness.

Following in the Puritan traditions, the pioneers continued to interpret wilderness in Biblical terms. In 1769, Eleazar Wheelock founded Dartmouth College in New Hampshire and gave it his motto, "Vox Clamantis in Deserto." His use of the term "desert" to describe the forest is reminiscent of the Old Testament. Many of the writings of Nathaniel Hawthorne extend the perception of wilderness as evil into the nineteenth century. The "moral wilderness" of *The Scarlet Letter*, where Hester Prynne wandered, represents freedom from social ostracism, but Hawthorne makes clear the potential for the temptations of evil.

As the idea of progress developed in the eighteenth and nineteenth centuries, Americans increasingly came to see their relation to wilderness in secular rather than religious terms. The

physical clearing of the wilderness was a symbolic act of progress and gave purpose to the early frontiersman's life. Many saw in wilderness the challenge of turning useless land into something beneficial for civilization. Most judged the wild environment in utilitarian terms and spoke and wrote of it in military metaphors, for example "conquering" the wilderness. Succeeding generations of these early settlers, living in cities, began to awaken to the ethical and aesthetic values of the wilderness condition (Nash 1967, 40–43).

Wilderness and Romanticism: Philosophy, Literature, and Artistic Expression

With the emergence and development of Romanticism in the eighteenth and early nineteenth centuries, the idea of wilderness lost its negative connotations and acquired powerfully positive ones. This change did not occur quickly, and general hostility toward the natural world remained strong in some quarters well into the mid–nineteenth century. The roots of this change can be traced to changes in European intellectual thought which eventually influenced American ideas. The concepts of the sublime and the picturesque were especially important elements in this change, as were deism and primitivism.

The concept of the sublime began to dispel the notion that beauty could be found only in tamed and well-ordered nature. Edmund Burke's *A Philosophical Enquiry into the Origin of Our Ideas of the Sublime and Beautiful* (1757) argued that pleasure in the contemplation of nature, and the arts that represented it, could be derived not only from the beautiful and orderly, but also from the terrifying and overwhelming. He proposed the concept of the "sublime," which included as elements of aesthetic response such experiences as awe and terror arising from encounters with the natural world, often wilderness, or with artist's depictions of such aspects of nature. Burke believed the sublime could be evoked in literature and painting but could not be re-created in the world in

a manmade architectural design (Ackerman 1993, 1–2). This concept was realized in nineteenth-century America by Thomas Cole and many other artists who worked in the Adirondacks.

The writings of Immanuel Kant, specifically his *Observations on the Feeling of the Beautiful and the Sublime* (1763) and *Critique of Judgment* (1790), prepared the philosophical groundwork that allied physical nature and aesthetics (Oelschlaeger 1991, 113–16). Interpretations of Kant's writings vary, some seeing an independence of aesthetics and others arguing a relatedness among aesthetics, morality, and nature, the latter being an essential element in the concept of wilderness in the Adirondacks in the second half of the nineteenth century.[2] As the sublime associated God and wild nature, the concept of deism incorporated the idea of the sublime as the basis for religion. Wilderness as pure nature was the clearest representation of God's power. The sublime and deism can be traced to the Enlightenment, and they prepared the foundation for Romanticism based on the natural environment. The Romantic preferred wilderness to ordered nature. Wilderness, which represented nature at its purest, unsullied by human activity, provided an escape from, and antidote to, society. It was a retreat where one could learn Nature's lessons through contemplation in solitude. A primary tenet of Romanticism was primitivism, which contended (among other things) that human happiness decreased in inverse proportion to the degree of civilization attained by humans. The mythical wild man seemed stronger and nobler than civilized man because of his closeness to Nature's influences. While civilized man was disadvantaged by life in society, he was able to restore himself by retreating to the wilderness for a day, a week, a year, or longer. Although the philosopher Jean-Jacques Rousseau did not advocate an idealized wilderness condition or a permanent retreat to the woods, he did argue in *Emile* (1762) that man should embrace primitive qualities in his life (Nash 1967, 46–49). In the generations that followed, these ideas influenced

2. Allen Megill's *Prophets of Extremity* argues the former and R. G. Collingwood's *Principles of Art* the latter.

travelers and writers who came to America from Europe, including Chateaubriand and de Tocqueville.

Stirrings of the spirit of Romanticism and appreciation of wilderness appear in the work of writers in America in the eighteenth century. An early example is William Byrd II, a Virginian who wrote *History of the Dividing Line* (1929), a description of the Appalachian region between North Carolina and Virginia. He was one of the first in America to describe the wilderness in other than negative terms. He referred positively to "this great Wilderness" when writing about his expedition into it. It is interesting to note that Byrd later revised this work to reflect the then-fashionable European interest in wilderness by adding passages about wild mountains.[3] Byrd lived on his large and prosperous plantation and accordingly could afford the luxury of admiring the wild landscape. Those who settled it would have experienced it differently.

Another early account with a Romantic outlook comes from a botanist, William Bartram, who, beginning in 1773, traveled through the southeastern part of the United States. Bartram's *Travels* records his impressions of the American landscape with such statements as being "seduced by these sublime enchanting scenes of primitive nature" when camping beside Lake George in Florida. For Bartram, the sublime in nature was directly associated with God, whom he referred to as "the supreme author of nature" (1958, 120–21, 229). In 1800, Benjamin Rush, a prominent Philadelphia physician, made the connection between wilderness and primitivism, noting that man is naturally a wild animal and is not happy away from the wilderness environment (1948, 72).

At the beginning of the nineteenth century, the writings of Thaddeus Mason Harris describe mixed impressions of the wilderness. Harris, a minister, in travels through the Alleghenies, acknowledged the relationship between nature and God but also referred to the "lonesome woods," which he found depressing at

3. Nash makes reference to the changes between the earlier version and the finished account, which are fully described in William Boyd's introduction to Byrd's book.

times. Harris preferred the wild state of nature. He wrote "THE SUBLIME IN NATURE captivates while it awes, and charms while it elevates and expands the soul" (Harris 1805, 71–72).

William Cullen Bryant was one of the first Americans to examine themes related to the wilderness in his work. *Thanatopsis* (1811) and *A Forest Hymn* (1825) both celebrate the beauty of nature. Bryant was influenced by William Wordsworth and the interest in the emotions associated with nature. Bryant allied America with nature, but Europe with history. Of the two, he preferred nature, as evidenced by the sonnet he composed in 1829 in honor of his friend, the artist Thomas Cole:

> *Thine eyes shall see the light of distant skies:*
> *Yet, Cole! thy heart shall bear Europe's strand*
> *A living image of our own bright land,*
> *Such as upon thy glorious canvas lies;*
> *Lone lakes—savannahs where the bison roves—*
> *Rocks rich with summer garlands—solemn streams—*
> *Skies where the desert eagle wheels and screams—*
> *Spring bloom and autumn blaze of boundless groves,*
> *Fair scenes shall greet thee where thou goest—fair*
> *But different—everywhere the trace of men,*
> *Paths, homes, graves, ruins, from the lowest glen*
> *To where life shrinks from the fierce Alpine air,*
> *Gaze on them till the tears shall dim thy sight,*
> *But keep that earlier, wilder image bright.*
> (Bryant 1887, 181)

The importance of the "wilder image" continued in subsequent literature in the early decades of the nineteenth century. One of the most widely read authors of this period was Nathanial Parker Willis, a prolific journalist with many magazine articles to his credit, but most noted for his *American Scenery* (1840). The work is a travel book, illustrated by the English artist William Henry Bartlett. The illustrations, often referred to as "Bartlett's Views," have become more familiar than the text, but the text reflected Willis's interest, and that of his readers, in prose descriptions of American scenery. Willis excluded the western part of the United

States of his time, and only two of the one hundred and nineteen engravings are from the southern states. The majority of the images are from the Hudson River–Lake Erie axis, which, thanks to the Erie Canal, was emerging as a tourist route during the 1830s when Bartlett made the illustrations and Willis wrote the text (Foster 1975, 10–12). Willis preferred American scenery's "lavish and large-featured sublimity" over European picturesqueness (Willis 1840, 1:v).

The expansion of the United States to the west was promoted by many writers. One with notably keen interest in its wilderness landscape was Washington Irving. His book *A Tour on the Prairies* (1835) was based on the journals he kept during his travels in the West and has many lengthy romantic descriptions of scenery. Irving often invoked European motifs in his descriptions of the American West (Foster 1975, 39), for example, in this reference to cathedrals of Europe:

> We were overshadowed by lofty tree, with straight, smooth trunks, like stately columns; and as the glancing rays of the sun shone through the transparent leaves, tinted with many-colored hues of autumn, I was reminded of the effect of sunshine among the stained windows and clustering columns of a Gothic cathedral. Indeed there is a grandeur and solemnity in our spacious forests of the West, that awaken in me the same feeling I have experienced in those vast and venerable piles, and the sound of the wind sweeping through them, supplies occasionally the deep breathings of the organ. (Irving 1835 [1956], 85)

Irving also cites idealized paintings of the American landscape by describing a scene as having "the golden tone of one of the landscapes of Claude Lorrain" (Foster 1975, 39). Though nearly every serious observer of American scenery commented on its distinctiveness from European scenery, they often resorted to European models of beauty and sublimity to describe it.

Another vital figure in arguing the value of wilderness is Henry David Thoreau. His works reflected the growing beliefs of Transcendentalism, which were becoming more widely known in

literary circles at midcentury. Different from Romantic or nationalistic views of nature, Transcendentalism was based on the relationship between the spiritual and the material, between God and nature. Man's place in this relationship is in the material world, but his soul gave him the potential to transcend it. By concentrating on nature, the individual could look beyond to an ideal world of the spirit. Wilderness was where man could be closer to this ideal state. Thoreau's views are highlighted and contrasted by discontent with civilized society. No doubt there was strong faith in progress generally, with commercial interests thriving, but many questioned the growing materialism around them. Thoreau's *Week on the Concord and Merrimack Rivers* (1849) and *Walden* (1854) explore the value in nature as well as espousing an opposition to materialism. Thoreau's thoughts and observations were highly valued and emulated through the second half of the nineteenth century (Huth 1957, 93–97). Thoreau was part of Ralph Waldo Emerson's circle, and in 1858 he visited the Adirondack wilderness with other "great men" from Boston in what was later described as the "Philosophers' Camp." In fact, camping in the wilderness was an activity written about frequently and was critical in developing the tourist industry in the Adirondacks specifically and in the United States generally.

Writers about the Adirondack wilderness included Charles Fenno Hoffman, Joel T. Headley, W. J. Stillman, and William H. H. Murray, all of whom helped to build the literary context from which Seneca Ray Stoddard emerged. The first popular book on adventures and travel in the Adirondacks appeared in 1839 in England and a year later in America. The book, *Wild Scenes in the Forest and Prairie*, by Hoffman was a compilation of magazine articles first published in the *New York Mirror*. The book included an account of Hoffman's trip into the Adirondacks, with stories of bears, rock slides, and a meeting with one settler who complained that the region was already being spoiled by civilization (White 1985, 101–2). The prose was relatively simple; the book did not cause droves of tourists to pack their bags in search of the Adiron-

dack wilderness. Another well-known author in the region was the Reverend Joel T. Headley, whose book, *The Adirondack; or, Life in the Woods,* reported that persons suffering from a variety of diseases seem to improve with a stay in the woods. Headley himself went to the Adirondacks to cure what he termed "an attack on the brain" (White 1985, 103–4). Headley's book was published in 1849 and remained in print through 1875. The book's anecdotal style made up in charm what it lacked in accuracy. W. J. Stillman, who studied painting with Frederic Church, traveled to England, returned in 1852 to become the art critic for the *New York Evening Post,* and cofounded in 1855 a journal of art criticism, *The Crayon,* originally went to the Adirondacks to heighten his "spiritual faculties" and found the solitude as important as the scenery (Stillman 1859 [1983], 76–85). He was one of the organizers with Emerson of the Philosophers' Camp at Follansbee Pond. His painting of the group remains an important record of American intellectual faith in the beneficence of wilderness. Stillman and others furthered the idea of exploring and camping in the woods, founding an "Adirondack Club" that lasted only a few years, owing to the onset of the Civil War.

The author who had a profound effect on the Adirondack region for many years after the war was the Reverend William H. H. Murray. His book *Adventures in the Wilderness; or Camp-Life in the Adirondacks,* was an anthology of his previously published articles from a Connecticut newspaper. Within six months of the book's appearance in 1869, great numbers of enthusiastic adventurers began traveling to the Adirondacks in what later was described as "Murray's Rush." Those same tourists were labeled "Murray's Fools" when they found the Adirondacks to be different from the conceptions they had formed from his descriptions of the wilderness, its lodgings, and its modes of travel. Despite the controversies surrounding Murray and his book, its publication was indeed a turning point in the creation of public perceptions of the Adirondacks. It described a lifestyle to which many aspired for short duration, and it was now in reach through improved rail,

water, and overland transportation. It seemed to allow a return to the simplicity, adventure, and beauty of the wilderness, as travel writers, philosophers, painters, and others had recommended. A number of critics ridiculed Murray's work, but none had an adverse effect on the interest in the region that his book had generated (Cadbury 1989, 54). A contemporary of Murray, the distinguished Boston orator Wendell Phillips, said that the book "kindled a thousand campfires and taught a thousand pens to write of nature" (Phillips 1904, 278).

To comprehend the pictorial art of the Adirondacks in this era requires a look first at European artistic production and its influence on American artists. In landscape, many of the conventions came from the work of Claude Lorrain, who in the seventeenth century conceived pictures that were "framed" with mountains in the distance, a middle ground with water, and a darkened foreground (Novak 1980, 228). The pastoral convention contributed to the image of America as a new Eden. Artists such as Thomas Cole held it in high regard. Dutch landscape drawing and painting of the seventeenth-century also had an impact on landscape representation in America. Novak argues further that the English landscape tradition influenced American painting. Claudian and Dutch motifs can be traced through eighteenth century English works in the ideal landscapes of George Lambert and the marine paintings of Samuel Scott, among others. In the nineteenth century, the work of Turner and Constable had a lasting influence on the developing American traditions (Novak 1980, 244–45). With the pastoral allusions of these artistic traditions in mind, American artists found an actual physical landscape, devoid of a past, upon which they could impose the ancient pastoral concepts (Crandell 1993, 141). The transition from the illusionistic to the actual landscape in America created a sense of sentimental pastoralism. Leo Marx describes this transition as follows:

> What is attractive in pastoralism is the felicity represented by an image of a natural landscape, either unspoiled or, if cultivated, rural. Movement toward such a symbolic landscape also may be

understood as movement away from an "artificial" world, a world identified with "art," using this word in its broadest sense to mean the disciplined habits of mind or arts developed by organized communities. In other words, this impulse gives rise to a symbolic motion away from centers of civilization toward their opposite, nature, away from sophistication toward simplicity, or, to introduce the cardinal metaphor of the literary mode, away from the city toward the country. When this wish is unchecked, the result is simple-minded wishfulness, a romantic perversion of thought and feeling. (Marx 1964, 9–10)

Following from this idea, Novak, in *Nature and Culture*, describes two distinct types of landscape painting in America in the nineteenth century: popular and luminist. The former includes large-scale paintings of the Hudson River School by Cole, Church, Cropsey, and Durand as well as paintings of the American West. The luminist works by Kensett, Lane, Heade, and others are based on earlier compositional conventions and developed a distinctive style.

The American school of landscape painting, which flourished beginning in the second quarter of the nineteenth century, was sometimes known as the "native" school and, after 1879, when the term came into use for the Hudson River School, was America's first recognized indigenous aesthetic movement. The Hudson River School painters attempted to possess nature by representing it, placing America's mark on the Enlightenment and the Romantic sublime tradition following the writings of John Ruskin. According to Horwitz, the Hudson River School was an appropriation of landscape, the continent, and American cultural heritage, with a goal to create a national identity. The American wilderness became the "central icon" in articulating the character of the nation (1991, 20–21).

The individual who epitomized the attributes of the Hudson River School was Thomas Cole (1801–1848). Coming from England in 1818, Cole found the American wilderness, specifically that of the upper Ohio Valley, deeply moving and decided upon an artistic career. He discovered the wilds of the Catskill Mountains

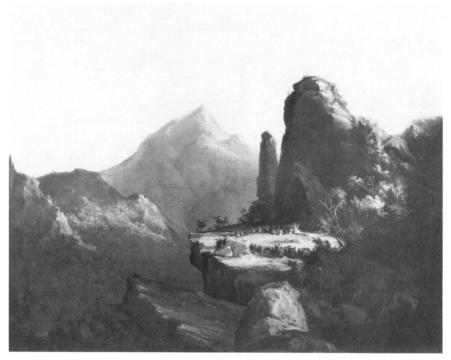

1. Thomas Cole, *Scene from "The Last of the Mohicans," Cora Kneeling at the Feet of Tamenund.* 1827. Oil on canvas, 25 5/16 x 34 5/16 inches. Wadsworth Atheneum, Hartford, bequest of Alfred Smith.

in 1825 and shortly thereafter exhibited pictures from the region. Cole's visit to Lake George, New York, in 1826 was inspired by his friend and admirer James Fenimore Cooper's publication of *The Last of the Mohicans*. The picture Cole produced in 1827, titled *Scene from 'The Last of the Mohicans,'* (fig. 1) depicts the close ties between an artist and a writer of the period. The real subject of the work, according to Robert McGrath, is not Cooper's narrative so much as it is the Adirondack wilderness and how it dominates human events (1991, 16).

After this initial success, Cole explored and produced sketches and paintings in various locations, including Schroon Lake in July 1837. The trip resulted in his *View of Schroon Mountain, Essex*

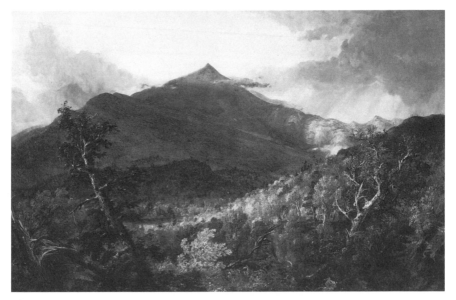

2. Thomas Cole, *View of Schroon Mountain, Essex County, New York, After a Storm,* 1838. Oil on canvas, 39⅜ x 63 inches. The Cleveland Museum of Art, 1997, Hinman B. Hurlbut Collection, 1335.1917.

County, New York, After a Storm (1838), now in the Cleveland Museum of Art (fig. 2). The picture depicts two gnarled trees in the middle foreground that emphasize the sun-splashed autumn red and yellow foliage. A foothill and then the mountain peak are set off by these sunlit colors. The sense of distance between the mountain and the viewer is achieved by the use of contrasting colors in atmospheric perspective, a characteristic of the American wilderness (Talbot 1969, 154–55). Cole described the area around Schroon Mountain as having "a wild sort of beauty." His famous "Essay on American Scenery," presented to the members of the National Academy of Design in 1835, and immediately published, became an important source in the articulation of wilderness philosophy for many generations of American artists (Cole [1835] 1965, 98–100). His assertion that "the wilderness is YET a fitting place to speak to God" echoes the writings of Bryant and others (Cole [1835] 1965, 100). Cole returned to the interior regions of the

Adirondacks in 1846, where he sketched at Long Lake and Indian Pass (Verner 1971, 85). It was around this time that Cole painted *Schroon Lake* (fig. 3), based upon sketches from his 1837 trip to the area. Patricia Mandel suggests that the hewn tree stump in the center foreground represents Cole's displeasure at the taming of the wilderness (1990, 44). The image of a frame-within-a-frame creates a distance between the viewer and the details of the landscape that echoes the changes and separation of man from nature.

A contemporary of Cole, Asher B. Durand, shared the same aesthetic and felt that the unspoiled American landscape offered painters an opportunity to develop an unusually high standard of

3. Thomas Cole, *Schroon Lake*, c. 1846. Oil on canvas, 33 x 32 inches. Courtesy of The Adirondack Museum.

technical proficiency in their work. In one of several letters that appeared in *The Crayon*,[4] Durand wrote:

> Go not abroad then in search of material for the exercise of your pencil, while the virgin charms of our native land have claims on your deepest affections. Many are the flowers in our untrodden wilds that have blushed too long unseen, and their original freshness will reward your research with a higher and purer satisfaction, than appertains to the display of the most brilliant exotic. The "lone and tranquil" lakes become embosomed in ancient forests, that abound in our wild districts, the unshorn mountains surrounding them with their richly textured covering, the ocean prairies of the West, and many other forms of Nature yet spared from the pollutions of civilization, afford a guarantee for a reputation or originality that you may elsewhere long seek and not find. (Durand [1855] 1965, 112)

Durand's painting *Kindred Spirits* of 1849 (fig. 4) depicts Cole and Bryant standing in communion overlooking a Catskill gorge. The picture was commissioned by Jonathan Sturges as a memorial to Cole and presented to Bryant in appreciation of the Funeral Oration that Bryant gave shortly after Cole's death. The image, including human figures, was a departure for Durand; he clearly felt the importance of the relationship of man and wild nature and not dominance over it (Flexner 1962, 68). This work represents a combination of the ideal landscape and a sense of realism in the details. There is a sense of community with nature and the artist and writer. Durand's scrupulous imitation of nature is seen as an act of piety, as part of his optimistic religious faith (Lawall 1971, 18–19).

The work of Frederic Church, who was Cole's student, portrayed the wilderness in a grander manner, with the Catskill Mountains as a primary subject. Church's later visits to northern Maine, particularly Mt. Katahdin in 1856, resulted in several paintings. Four years later he painted *Twilight in the Wilderness* (fig. 5), which is similar to Cole's and Durand's images of the American wilderness as an artistic expression. Elements of the

4. For a full description of the subject of the American landscape in the nineteenth century related to *The Crayon*, see Grzesiak 1993.

Adirondacks and the Concept of Wilderness

4. Asher B. Durand, *Kindred Spirits*, 1849. Oil on canvas, 44 x 36 inches. Collection of The New York Public Library, Astor, Lenox and Tilden Foundations.

pastoral landscape are gone as the picture plane looks from a spruce-covered cliff over a river to the mountains in the distance. The focal point of the picture is the flamelike clouds casting a glow upon the landscape below. David Huntington suggests that the brilliant sunset is symbolic of apocalyptical expectations

5. Frederic Church, *Twilight in the Wilderness*, 1860. Oil on canvas, 40 x 64 inches. Copyright The Cleveland Museum of Art, 1997, Mr. and Mrs. William H. Marlatt Fund, 1965.233.

(1966, 71–83). Novak argues that the sky represents "reciprocal energies" of realism, and abstract invention creating a definition of divinity (1980, 98). Church's painting *Heart of the Andes* (fig. 6) celebrates American progress and was probably the single most publicized and profitable painting of the nineteenth century (Avery 1986, 52–72). When the picture was exhibited with the portraits of America's founding fathers, the work took on an allegory of nationalism. It was also considered a pictorial affirmation of God in nature (Huntington 1966, 51–52). Church's work and that of other Hudson River School painters was a departure from the Claudian compositions, as it lacked the heroic, ideal intention and "general principle" of nature (Novak 1980, 73).

Turning from the popular paintings of the Hudson River School to an exploration of the equally important concept of luminism in nineteenth-century American painting, Novak has suggested light as the single most important spiritual element in American land-

scape art. Light was often transformed by painters to symbolize religious expressions based on Transcendental philosophy, which was discussed earlier. Novak's essay "On Defining Luminism" describes the concepts associated with luminism, beginning with its structure. In composition, luminist paintings consist of a horizontal plane with an extended format that moves the viewer's eye back into the space. There are examples where short verticals contrast with the generally horizontal plane. There is also a contrast between the real and the ideal landscape, with natural landscapes in an abstract order. Sources for these compositional elements are found in Claude Lorrain and in seventeenth-century Dutch art as described earlier (Novak 1989, 23–25).

Novak describes other characteristics of luminism, including light and brushstroke. Light appears to have a crystalline quality, not a painterly quality with recognizable brush strokes. The light is cool and hard as opposed to warm and soft as in many Hudson River School paintings. In addition, Novak notes that luminist

6. Frederic Church, *The Heart of the Andes,* 1859. Oil on canvas, 66⅛ x 119¼ inches. The Metropolitan Museum of Art, Bequest of Mrs. David Dows, 1909 (09.95).

paintings are often physically small, while the space they depict is quite large (1989, 25–28).

In contrast to the popularity of the Hudson River School paintings, luminist work had a small but devoted audience. Novak further suggests that artists may have distinguished between private and public roles for which certain conventions were used and that private and public taste existed (Crandell 1993, 10).

Luminist pictures have long been believed to focus on a spiritual experience. John Frederick Kensett's *Lake George* of 1869 (fig. 7) is but one example of how the landscape seems virtually transparent to the power of light. The visual corollary of silence is stillness, and both are in contrast to the noise and action of many Hudson River School pictures, for example, Durand's *Progress* (fig. 8) (Crandell 1993, 146).

Many of the characteristics of painting on the national scene relate directly to artistic representation in the Adirondack region.

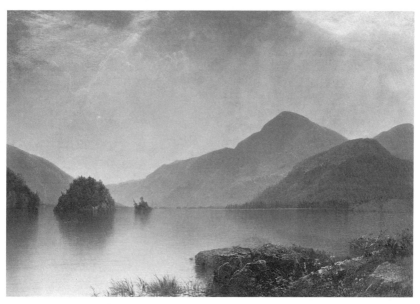

7. John Frederick Kensett, *Lake George*, 1869. Oil on canvas, 44 x 66¼ inches. The Metropolitan Museum of Art, Bequest of Maria de Witt Jesup, 1915 (15.30.61).

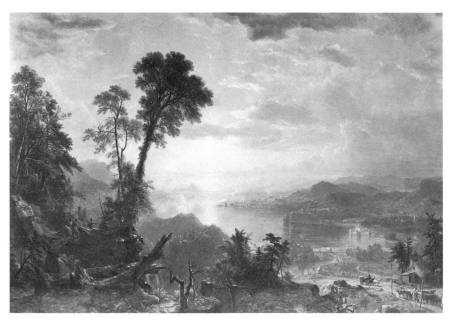

8. Asher B. Durand, *Progress*, 1853. Oil on canvas, 48 x 71 15/16 inches. Courtesy of the Warner Collection of the Gulf States Paper Corporation, Tuscaloosa, Alabama.

Mandel suggests that purity of light and its effect on color is responsible for two archetypal images in Adirondack painting—the orange-reds of sustained sunsets and the dark blue shadows that outline snowcaps from the winter sun (1990, 13). Sanford Gifford's *A Twilight in the Adirondacks* (fig. 9) is an example of the former. Ila Weiss describes the painting at the hour when "an irregular horizontal band . . . marginally legible as pines and deciduous tree [appears] against the filed of pinkish-orange and yellow light of sky and water" (1977, 240). The work represents the Emersonian transcendental philosophy of the spiritual over material nature. In contrast, the absence of color, white, is an often-employed effect as evidenced by the snowy scene of Arthur Fitzwilliam Tait's *Snowed In* (fig. 10) (Mandel 1990, 13–14).

Surveyors were often the first to sketch the area, more for cartographic than aesthetic reasons. In 1837, the artist Charles

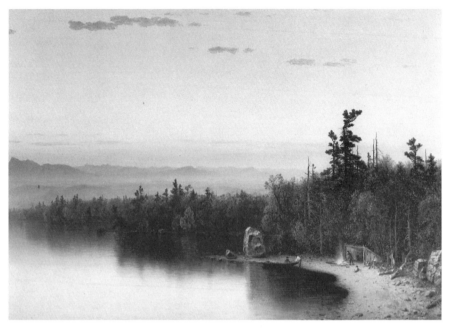

9. Sanford Gifford, *A Twilight in the Adirondacks*, 1864. Oil on canvas, 24 x 26 inches. Courtesy of The Adirondack Museum.

Ingham accompanied William Redfield, who was surveying the Adirondack Pass, also known as Indian Pass. Ingham's painting *The Great Adirondack Pass, Painted on the Spot* resulted from the trip and was exhibited at the National Academy of Design. Thomas Cole, a member of the National Academy, most likely saw the picture and may have been influenced by it.

A number of artists were affected by the American Civil War, including Jervis McEntee, Roswell Shurtleff, Horace Robbins, and Gifford. All lived in New York City but summered in Keene Valley, which became the Adirondacks first artists' colony after the war. The Keene Valley artist saw the landscape as a place of peace amidst the chaos of the larger world. Mandel characterizes the work of these artists, such as Ingham's early work, as private rather than documentary views (Mandel 1990, 18). The same interest in tranquility inspired luminist paintings of Adirondack

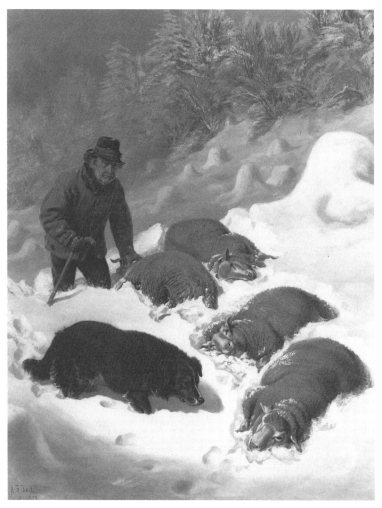

10. Arthur Fitzwilliam Tait, *Snowed In*, 1877. Oil on canvas, 36 x 28 inches. Courtesy of The Adirondack Museum.

landscapes, including the work of N. A. Moore and Alfred T. Bricher, although Kensett's *Lake George*, described previously, is probably the most notable example.

Another important artist who was active in Keene Valley was Winslow Homer (1836–1910). Beginning in 1870 and over the next

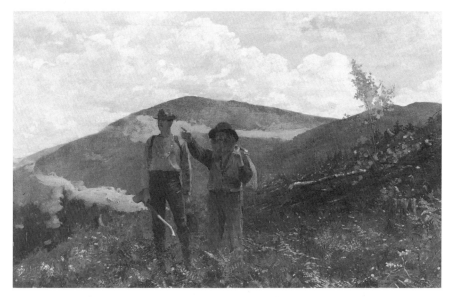

11. Winslow Homer, *Two Guides*, c. 1876. Oil on canvas, 24 1/4 x 38¼ inches. Sterling and Francine Clark Art Institute, Williamstown, Massachusetts.

four decades, the Adirondack landscape and its inhabitants served as Homer's inspiration in summer (Tatham 1988, 41). *Two Guides* (fig. 11) is but one example. Homer depicted the enjoyment of hunting, fishing, and other recreational activities in the wilderness setting. His works were often purchased by wealthy urban residents, some of whom had explored the region as tourism developed in the 1860s and 1870s.

The news of the "discovery" of photography in 1839 by Louis-Jacques-Mandé Daguerre in France quickly found its way to America. The period in which the medium was introduced and developed was one of rapid change, difficult economic conditions (the 1837 financial panic created extremely high inflation), and important technological changes such as the invention of the steamship, railroad, and telegraph. Within months of the discovery, a variety of itinerant entrepreneurs were setting up shops to make daguerreotype portraits following in the painter and limner

traditions. During the 1840s two types of daguerrean practices developed: the rural itinerant photographer traveling the countryside and the city entrepreneur with all the trappings of an art gallery and studio (Trachtenberg 1989, 22).

A well-known figure who took advantage of and explored the entrepreneurial possibilities was Mathew Brady. In 1850, Brady published *The Gallery of Illustrious Americans,* which contained twelve daguerreotype portraits of famous Americans ranging from John James Audubon to Henry Clay. The images were reproduced as lithographs by Francis D'Avignon.[5] The issue that many of these entrepreneurs faced was concern for the artistic value of photomechanical images. Brady addressed this issue in the April 10, 1854, edition of the *New York Tribune,* in his "Address to the Public":

> Being unwilling to abandon any artistic ground to the producers of inferior work, I have no fear in appealing to an enlightened public as to their choice between pictures of the size, price and quality which will fairly remunerate men of talent, science, and application, and those which can be made by the meanest tyro. I wish to vindicate true art, and the community to decide whether it is best to encourage real excellence or its opposite; to preserve and perfect an art, or permit it to degenerate by inferiority or materials which must correspond with the meanness of the price.

Although portraiture was the initial and most prevalent use of the new medium, many other uses were made of photography, including documenting the American Civil War and westward expansion, and it became a form for artistic expression soon after. Photographs could be seen as primary source documents and as a new form of mass education. It is also important to view them in the context in which they were taken. Photographs of the Civil

5. According to Trachtenberg, the title of Brady's book continues: "Containing the Portraits and Biographical Sketches of Twenty-Four of the Most Eminent Citizens of the Republic since the Death of Washington" (1989, 296). Twenty-four represented the original plan, but sales did not warrant continuing after the first year. Also, 1851 is the date of the bound volume of the twelve prints issued monthly in 1850.

War bring together medical, religious, political, and legal illusions into single images, which Alan Trachtenberg believes can alter ways of seeing and using the images. In describing the use of photography in the Civil War, Joel Snyder suggests that photographs incorporate formal devices that attempt to assure the viewer that there is no "narrator." This effect was accomplished by employing a standing point of view, emphasizing clarity and fine detail, and moving back into the picture frame to show everything. In effect, the illusion represents a form that appears to have been created from no form at all (Snyder 1976, 22).

After the Civil War, cities grew with increased industrialization, as did a sense of the human need to explore and ultimately dominate nature, particularly the wilderness of the American West. New spaces were literally and figuratively created. There are numerous examples of early white explorers renaming locations; the Yosemite Valley was in fact originally Ahwahnee, a name given by the Indians (Trachtenberg 1989, 126). The confluence of science, philosophy, and artistic expression through photography provided a means not only for understanding new spaces but for exploiting them. Images of newly discovered and surveyed land could also make it appealing for potential investors. With the building of the transcontinental railroad, beginning with the completion of the Union Pacific in 1869, and the subsequent development of the cattle industry of the 1860s and 1870s, as well as the discovery of gold and silver, the western United States expanded rapidly. Some photographers employed by the railroad companies photographed the construction progress for owners, with the landscape being incidental background. John Carbutt and A. J. Russell were hired by the Union Pacific for this purpose, as was Alexander Gardner by the Kansas Pacific Railroad (Cawelti 1976, 25). Others combined entrepreneurial intentions with the Western geological surveys organized and funded by the United States government.

In four major government-sponsored surveys, photographers were included as well as artists. Timothy O'Sullivan and Carleton Watkins were part of the King Survey of the 40th Parallel, William

Bell and O'Sullivan joined the Wheeler Survey of the 100th Meridian, William Henry Jackson worked with the Hayden Survey, and John K. Hillers accompanied the Powell Survey of the Colorado River.

The photographs produced from the surveys were created to serve a variety of purposes. They were often published with the survey reports, sold to newspapers and magazines to be used for engravings, bound together for collectors or investors, or sold directly to the public as souvenirs, often as stereographs or cartes de visite. According to Martha Sandweiss, early photographers faced a variety of problems. Unlike the daguerreotypist in the studio, who worked on a commission, survey photographers had no immediate audience. Furthermore, the intrinsic value of the descriptive images was not apparent. Americans were accustomed to learning about the wilderness of the West through paintings and prints and were disappointed in early photographs, both as documentation and as imaginative symbols of the landscape (1991, 100).

To understand landscape photography in the nineteenth century, it is important to know what is meant by landscape, an often ambiguous term. Jussim and Lindquist-Cock think of the term as a construct. Landscape is both scenery and environment but is equivalent to neither. When landscape is thought of in terms of the phenomenological world, it does not exist; landscape can only be symbolic. As constructs and as artifacts, landscapes are saturated with assigned meanings (Jussim and Lindquist-Cock 1985, xiv). D. W. Meinig believes that, like nature, what we call landscape is "defined by our vision and interpreted by our minds." He goes on to say, "Environment sustains us as creatures, landscape displays us as cultures" (Meinig 1979, 2–3).

Among recent criticism related to photography and the subject of landscape, the work of Rosalind Krauss is important to examine. With particular regard to the nineteenth century, Krauss suggests that art historians have created aesthetic objects from photographs that were originally taken in the context of the survey of the West.

39

Krauss uses the example of Timothy O'Sullivan and his use of the term "view" rather than "landscape." View corresponds to authorship in that the point of interest confronts the viewer without the mediation of the photographer. The view depicts an image of geographic order, and landscape represents the space of an autonomous art and its idealized history, which is constructed by aesthetic discourse. Krauss also thinks that recent scholars of photography have decided that certain images are landscapes rather than views and that fundamental concepts of aesthetic discourse are applicable to the visual archive. She questions the use of terms such as "career" and "oeuvre" when discussing nineteenth-century topographical photography and photographs. Can the word "artist" be associated with such photographs? (Krauss 1982, 311–19). One can argue that O'Sullivan produced stereographs for public consumption and large plates for the governmental surveys, two different audiences, and that the former may have been executed with aesthetics in mind. This and related questions will be considered with the subsequent review and evaluation of Stoddard's work.

Another important concept related to mid–nineteenth century photographic images is that of luminism. Weston Naef suggests that the "classic" period of American photography (1860–80) centered on nature and on the use of light as a resource, not simply a condition. The earlier phase, which he terms "archaic" (1840–60), is represented by the daguerrean image, in which, because of the limitations of the process, outdoor light and space were seldom used. The later phase, through 1900, was an extension of the classic phase and took advantage of improved materials to produce more literal effects (1989, 267). Naef maintains that luminism had its parallels with American landscape painting of the period. The use of crystalline light; interest in atmospheric conditions; an appreciation of beauty in nature; flat, open, palpable space; simplification of forms; and an avoidance of literary associations were all characteristics of luminism.

Naef sees the photographic images with these traits as "pure thought," at times surpassing the work of some artists in their ability to render nature and atmospheric conditions (1989, 288). The works of Southworth and Haws in Boston in the 1850s and of Carleton Watkins, Timothy O'Sullivan, John Soule, Henry Rand, and Seneca Ray Stoddard all employed luminist characteristics.

The philosophical, literary and artistic representations of wilderness changed, as did the nation's economic conditions and cultural values. Within the context of these traditions, we can examine Seneca Ray Stoddard's contribution to the concept of wilderness in the Adirondacks through his written and visual documentation.

2 Seneca Ray Stoddard as a Writer

t age nineteen, Stoddard began his career as an ornamental painter of railroad cars in Troy, New York, not far from his birthplace in Wilton, town of Moreau, Saratoga County. His birth date of May 13, 1843, has been disputed—not the month or day, but the year. Harold Smith's *History of Warren County*, published in 1885, cites 1843, while newspaper obituaries and Stoddard's tombstone in Pine View Cemetery in Glens Falls give 1844 as his year of birth. Interestingly, the obituaries give April 26, 1917, as the day of his death, although a chronology in William Crowley's exhibition catalogue of 1982 gives May 3 of the same year.[1] Despite these conflicting records, Stoddard began, developed, and concluded a career of nearly fifty years with Glens Falls as the geographical base of his artistic and entrepreneurial endeavors.

After two years of railcar decorating with the firm of Eaton and Gilbert, he opened his own shop in Glens Falls, advertising in the *Glens Falls Republican* of August 23, 1864: "House, Sign, and Ornamental Painting." During this period he most likely learned basic photography techniques from a local photographer, but there is no known documentation to verify this supposition (Fuller 1987b, 1). During this early period Stoddard began making stereograph views in and around Glens Falls. He traveled by foot, bicycle, and train to take pictures of Lake George, Ticonderoga, Crown

1. "S. R. Stoddard at Journey's End," *Glens Falls Times and Messenger,* Apr. 26, 1917. Same obituary appeared in the *Post-Star,* Apr. 27, 1917, with a reference to the date of death the previous day. The May 3 date is listed in Crowley (1981–82, 64).

Point, Lake Champlain, and Ausable Chasm ("Pictorial Record" 1963, 14). At the same time, Stoddard produced portrait and landscape paintings. The 1870 census lists him as a "landscape painter" (U.S. Bureau of the Census 1870). By 1867, Stoddard was known locally for his photographic work. An article in the *Glens Falls Republican* of October 1, 1867, states:

> Mr. S. R. Stoddard, Photographer, has taken a number of instantaneous stereoscopic views of natural objects in this vicinity, especially about our beautiful falls, which are not only interesting and valuable to residents here, but possess real merit as a collection of scenery hardly excelled by those produced from any locality in the United States. He has also photographed our banks and churches and several private dwellings. . . . Mr. S. has chosen his objects with the eye of an artist, and his work is well and faithfully done.

Stoddard made his first trip to the interior of the Adirondacks in the fall of 1870, within a year of the publication of William H. H. Murray's *Adventures in the Wilderness.* The trip was noted in the local newspaper (*Glens Falls Republican,* Nov. 15, 1870) but no sketches or photographs have been documented. Stoddard was accompanied by Charles Oblenis, his brother-in-law and assistant. They are reported to have photographed Ausable Chasm and spent several days in the Blue Mountain Lake and Long Lake areas (DeSormo 1972, 41). Stoddard's second trip to the interior regions of the Adirondacks, made in 1873, is documented by a sketchbook, now in the collection of the Adirondack Museum, and by many surviving photographs. Equally important, this three-week trip served as the basis for Stoddard's *Adirondacks Illustrated* series and the short-lived *Northern Monthly.*

While Stoddard was taking photographs, his wife, Helen Augusta Potter, whom he had married in 1868, and several other women managed the production of the images and attended to the details of marketing his work. The photographs Stoddard produced during the first two decades of his career were primarily albumen prints, which entailed a labor-intensive process. Unlike other landscape stereographers of the time, such as the Kilburn Brothers

in New Hampshire, Stoddard made large prints measuring 6½ by 8½ inches (full plate) and 14½ by 18½ (mammoth) (Fuller 1987b, 1). Later in his career, for his work in Alaska, Stoddard is said to have designed a camera to make negatives measuring 20 by 49½ inches. During the trip the camera failed, but eventually it was perfected and was considered the largest camera in the world at the time (DeSormo 1972, 124). With the production of these images, Stoddard's business interests expanded. In addition to the guidebook series that began in 1873, Stoddard sold individual photographs as well as souvenir albums of particular locations such as Lake George and Ausable Chasm, and he produced promotional brochures for hotels in the region.[2] E. & H. T. Anthony & Company of New York City, one of the largest distributors of stereo views offered Stoddard's views of Lake George as part of their Christmas selection in 1871 (Welling 1976, 78). In the 1874 edition of *Lake George Illustrated* Stoddard offered six hundred stereo views, one hundred 8 x 10 photographs, and one hundred 11 x 14 photographs, "many of them designed especially as Studies for Artists" (*LGI* 1874, 200).

The mid-1870s record several other milestones in Stoddard's career that should be noted. In 1876, he exhibited his photographs in the Philadelphia Centennial Exposition. The following year he published his *Catalogue of Photographs of New York Scenery,* and in 1878 he was hired by Verplanck Colvin to oversee the photographic work of the New York Topographical Survey of the Adirondacks. Stoddard produced approximately two hundred panoramic views as part of this survey work. These images, produced over several years, were primarily 360-degree panoramas taken from mountain tops (Crowley 1981–82, 5).

2. There are numerous examples of these works in the Stoddard manuscript collections held by the Adirondack Museum and the Chapman Historical Museum. *The Hemlocks, Raquette Lake, N.Y.,* produced by Stoddard, describes the Raquette Lake region and the accommodations and amenities of the hotel including prices and directions. Several photographs are included. Stoddard's work and his relationship with the hotel operators were interconnected as Stoddard included descriptions of the hotels in his guidebooks and the hotels often sold his photographs in their establishments.

During the 1880s Stoddard received a number of commissions, specifically from railroad companies to document the attractions and scenery visitors could see when traveling in the Adirondacks. The Adirondack Railroad Company and the Central Vermont Railway, among others, hired him, and this work led to private commissions from wealthy Adirondack developers such as Dr. Thomas Clark Durant and his son William West Durant. Stoddard produced photographic albums for these and other clients, sometimes unique oversized volumes, called elephant folio albums, that measured upwards of 26 by 40 inches. Albums of the camps Pine Knot and Sagamore are but two examples that William Crowley has documented from Stoddard's letters and account books.[3]

Stoddard was an enterprising photographer in many ways. In 1882, he was issued a patent for a photographic plate holder, which was produced and distributed by the E. L. Eliot and Company of Auburn. As the number of amateur photographers grew in the 1890s, Stoddard became a distributor for Kodak film, cameras, and other supplies.[4] He eventually went into the photo processing business and offered instruction to interested amateurs in addition to his ongoing production of photographs and publishing. He is credited with creating as early as the mid-1880s some of the first photographs exposed at night using magnesium flash powder. His night views of New York City's Washington Square Memorial Arch and "Liberty Enlightening the World" in 1890 were well documented in their time.[5] Stoddard also used the flash technique for night campfire images in the Adirondack woods.

3. William Crowley cites the Adirondack Museum's *Durant Collection*, MS 63-258, Letter Book: William W. Durant to S. R. Stoddard, July 3 and 6 and Aug. 23, 1899, and June 5 and 26, 1900.

4. A brochure entitled *Stoddard Combination Plate and Film Holder* and a copy of the patent no. 257408 are in the manuscript holdings of the Adirondack Museum, MS 75-2, box 1, bolders 4 and 5. References to distribution of photographic supplies can be found in the Adirondack Museum's *Stoddard Account Book*, 1879–1914, 81, 85, 88, 237, 322, 414.

5. John Fuller (1987a, 217) cites an article, "Taking Pictures at Night" from the *New York Tribune* of March 2, 1890, which describes how Stoddard used five cameras focused on the Statue of Liberty with pulleys connecting the flash powder to an

A critical event in Stoddard's career, and one that had a dramatic impact on the Adirondacks, was his lantern slide presentation before the New York State Assembly in February 1892. The lecture, which was repeated in the following months in other cities around the state, was intended not only to show the beauty of the Adirondacks, but also to generate interest in the idea of protecting the land from human destruction. In May 1892, legislation signed by Governor Flowers established the Adirondack Park and led to the "forever wild" designation two years later. Stoddard's illustrated lectures on the region were an important factor in securing this legislation (Mitchell 1992, 53–54).

Stoddard's publications, lectures, and photographs continued. He remained active into the second decade of the twentieth century. During these later years, he traveled to the American West (1894), the Mediterranean and the Near East (1895), Great Britain, Russia, and Scandinavia (1897), and to Germany and France (1900) and attended the Paris Exposition in that year. In 1909, he published his *Chart of Lake George*, a hydrographic survey, which he had worked on for several years.

Two years before his death in 1917, Stoddard's *Picturesque Trips Through the Adirondacks* was published and marked the region's transition to the automobile. His "Greeting" in the introductory page to this guide offers a retrospective view:

> I made my first trip to the heart of the Adirondack Wilderness in
> 1873, covering a series of loops in its more noted sections and
> routes, and gave the results of the experience the following year in
> narrative form.
>
> Changes? Wild grass grows on the old routes and the unknown
> places of then are now centers of a summer population greater
> than the total of all Adirondack visitors of twenty years ago.
>
> Railroads encircle the Adirondacks like the iron frame of a
> landing net. From the encircling lines others penetrate the interior,
> crossing each other and branching in turn to reach important

electrical generator by way of a copper wire. The use of a pound and a half of magnesium produced a dramatic affect and was extremely dangerous owing to the strength of the explosion.

points, or lose themselves among the mountains or in the watery highways that are woven in a network all over the lake region of the west.

It is truly a new Adirondacks. From the early days, when travel was undertaken in devious ways by primitive means, it has become a wilderness traversed by magnificent state highways, forming a network of roads as fine—the major portion, at least—as the boulevards of our cities (*PT* 1915, 2).

Stoddard as Writer and Publisher

In Philip Terrie's introduction to his *Forever Wild: Environmental Aesthetics and the Adirondack Forest Preserve*, he describes the concept of wilderness: "The landscape constitutes a wilderness to the extent that people perceive it to do so. Thus wilderness is both an objective, geographic entity, a physical place defined by the fact that the human is a visitor there, and also a subjective, psychological phenomenon, defined epistemologically by the mind of that visitor" (Terrie 1985, 11–12). He goes on to quote Thoreau in his perception of the Maine woods, which applies equally to the Adirondacks, by saying, "Generally speaking, a howling wilderness does not howl: it is the imagination of the traveler that does the howling" (Thoreau 1864 [1972], 219). If the "imagination of the traveler" is indeed influenced by the written word, Stoddard's writing and publishing on the Adirondack wilderness influenced many.

The tradition of romantic travel literature in America had been established by the mid–nineteenth century with works such as Joel T. Headley's *The Adirondack; Or, Life in the Woods* (1849). Headley's book incorporated all the standard components of the genre including instructions for preparing for a trip to the Adirondacks, detailed descriptions of hunting and fishing, general accounts of life in the woods, and generic descriptions of scenery. His audience consisted predominantly of affluent Easterners desiring a retreat from urban life to a place "where they could restore their physical, mental and moral fortitude" (Terrie 1985, 45). The

romantic literature of Emerson in his poem, "The Adirondacks: A Journal Dedicated to My Fellow Travelers in August, 1858," and Hoffman's *Wild Scenes in the Forest and Prairie,* offer depictions of the aesthetic qualities of the wilderness landscape. They differed from other romantic writers who valued more the productivity of the land and saw fields of crops and bountiful farms as enhancers of the beauty of the landscape.

Another point of view, and one rarely heard at that time, appeared in the works of Samuel H. Hammond. Hammond eloquently expressed an appreciation of the delicate balance between wilderness and nature and the need to preserve the wilderness. Hammond states:

> When that time shall have arrived, where shall we go to find the woods, the wild things, the old forests, and hear the sounds which belong to nature in its primeval state? Whither shall we flee from civilization, to take off the harness and ties of society, and rest for a season, from the restraints, the conventionalities of society, and rest from the cares and toils, the strifes and competitions of life? Had I my way, I would mark out a circle of a hundred miles in diameter, and throw around it the protecting aegis of the constitution. I would make it a forest forever. It should be a misdemeanor to chop down a tree, and a felony to clear an acre within its boundaries. The old woods should stand here as God made them, growing until the earthworm ate away their roots, and the strong winds hurled them to the ground, and new woods should be permitted to supply the place of the old so long as the earth remained. (Hammond 1857, 33–34, 82–84)

Ideas such as these mark the beginning of changes in the perception of the land that would be fully realized only several decades later. With the conclusion of the Civil War and the publication of W. H. H. Murray's *Adventures in the Adirondacks* in 1869, the backdrop of the "gilded age" was set for changes in how the Adirondacks were portrayed in print.

Stoddard developed his career as a guidebook writer within a continuing tradition. He combined his talents as writer, cartographer, artist, and photographer in producing his guidebooks. Each of

these elements was important to the overall success of the publi-cations.[6] Stoddard was well-known for the creation and sale of maps of the Adirondacks (fig. 12) depicting the areas he described in his guidebooks and subsequently photographed. Stoddard's first published guidebook, *Lake George; Illustrated* (1873), was reis-sued in revised editions annually through 1914.[7] The early edi-tions were clothbound (1873–1908) and the later ones were issued in paper wrappers.

Initially, *Lake George; Illustrated* included descriptions and in-formation related only to Lake George; subsequent editions added Saratoga, Luzerne, and Schroon Lake. The title page remained the same, but the new locations were added to the spine of the book. It is interesting that in 1881 the Saratoga section was removed from the work proper and added as a separate section but bound upside down in the same volume. The reverse cover has the Saratoga title, and therefore the book could be picked up on either end, front and back. Stoddard used this arrangement and binding through 1902. One can speculate that this type of binding arrange-ment was not only practical for the reader being in the one loca-tion or the another but was also a clever marketing device. The titles of sections also changed with succeeding editions; *Lake George* became *Lake George and Lake Champlain: A Book of To-day*. By 1902, with a return to the traditional binding arrangement, the title became *Saratoga, Lake George (Illustrated) and Lake Champlain; A Book of Today*. In 1909, Saratoga was removed from the title, but the section of the book was retained.

6. Warder Cadbury, in the introduction to the 1970 edition of Murray's *Adven-tures in the Wilderness* (54) notes that a number of guidebooks devoted solely or in large part to the Adirondacks were published during the same period, including Colt (1871), Faxon (1873), and Bachelder (1875).

7. According to DeSormo, the book was first published in 1871. The 1874 edition includes an introduction, which Stoddard states is from the first edition, dated May 1873. A chronology and bibliographic descriptions of Stoddard's published works were documented by William Crowley of the Adirondack Museum in preparation of the exhibition catalogue, *Seneca Ray Stoddard: Adirondack Illustrator*, published in 1981 by the Adirondack Museum. Crowley's chronology has been useful in the initial bibliographic organization for the present study of Stoddard's work.

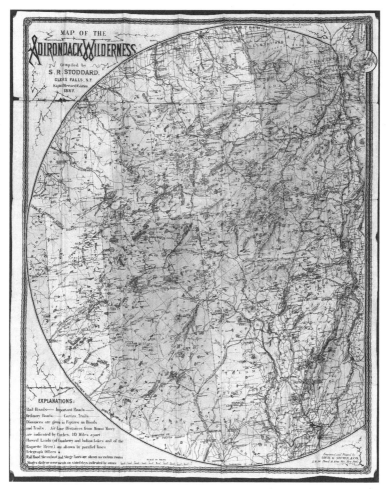

12. *Map of the Adirondacks*, Glens Falls, New York, eighth (revised) edition, 1887. Private collection.

As with Stoddard's numbering system for photographs, confusion has arisen about the number of editions of *Lake George; Illustrated.* The 1888 edition was the first to be given an edition number, and it was assigned "18th," though the book had been in publication for only sixteen years. Most likely, Stoddard considered the paper and cloth editions of 1873 and 1874 to be separate

edition numbers. Also, various editions included maps of Lake
George with some changes and revisions. The early editions
included engravings by Stoddard. In 1888 the first photograph ap-
peared in a railroad advertisement. In 1895, numerous photo-
gravures accompanied the text. These latter changes will be
discussed in the section on Stoddard's photographs.

The text of *Lake George; Illustrated* begins with Stoddard's
preface, in which he asserts:

> A STRONG conviction of duty, a laudable desire to give informa-
> tion, and a philanthropic willingness to contribute something, in
> shape of advice, to a long suffering people, coupled with the known
> fact that the public demand some source wherefrom can be drawn,
> as from a living fountain, supplies of knowledge, has induced the
> author, in a fit of temporary insanity, to attempt the semi-literary
> feat of perpetrating a guide book. (*LGI* 1873, 3)

The combination of elaborated structure, stock altruism, and
tongue-in-cheek self-deprecation is typical of Stoddard's style and
makes his prose livelier than that of other guidebooks of his time.
He goes on to describe what he feels will be his distinctive contri-
bution to the genre:

> I will point out places where it is considered eminently proper to
> go into the ecstasies over scenery, etc. I am not going to write a
> history, however, because the wear and tear on an ordinary brain
> must be immense; and, moreover, the country is full of them. All
> others who have written of the silvery lake have made discoveries,
> I have not. I regret exceedingly that such is the case. I have, how-
> ever, served the principal events up in a new dress, and in the light
> of later revelations, twisted some of the old ones so as to answer
> every purpose; but it all happened some time ago, is, consequently
> of little interest to the general reader, and has, therefore, been
> given in small doses, which may be skipped at pleasure for the ho-
> tels and other things of the present day. (*LGI* 1873, 3)

While distancing himself from written history, Stoddard none-
theless goes on to thank a historian, Dr. A. W. Holden, for advice
and help related to the historical aspects of the guide and at the
same time indicates in the passage above the liberties he will take

to make history interesting to the general reader. Stoddard ends the preface by bidding "farewell to early fears," and "wades shiveringly into the surging sea of literature." It is interesting to note that the preface is titled Ego, which appears on the first page as part of the illustration, which includes a human eye. This word also appears as part of the title of a proposed periodical, *Egoland*, which Stoddard envisioned around 1900 but never published. The use of the word *ego* is an obvious reference to the self, as in his preface, and to his highly individualistic reading of the world around him, and it may also refer to Stoddard's idea of the divine, for in his own idiosyncratic way, he was a religious and spiritual individual.

Most of the text of the book related to Lake George describes the various means of transportation to and from the region, hotels, and a mix of historical and anecdotal stories related to certain landmarks. There is very little description of or reference to wilderness, or even to the general scenic beauty or aesthetic rewards of the Lake George region, with the slight exception of the opening lines of the section: "Off for Lake George! How the heart bounds and the pulse quickens at the very sound of the words that bring with them thoughts of the holy lake. In fancy we once again breathe the air, heavy with the odor of pines and cedar, or fragrant with the breath of blossoming clover. (*LGI* 1873, 6).

The sections on Luzerne, Schroon Lake, and Ausable Chasm have descriptions of scenery worth noting. In describing the "drives" around Luzerne, Stoddard says:

> There are a great many beautiful drives around Luzerne, the miniature grandeur—if I may be allowed the expression, but it seems but a reduced copy of grand mountain groups and ridges—of the river above, and quiet beauty of the scenery below, offers rare contrasts and scenes in keeping with every mood. One especially lovely trip is down along the west shore of the river, that is here almost always in a quiet mood where the trees that hang over the glossy stream appears no more perfect than those below, to Palmer Falls, then returning to Jessup's Landing. (*LGI* 1873, 154)

Stoddard also weaves into the description, "For catalogue of photographs, see Appendix," so the reader is aware the photographs are available for purchase.

Stoddard describes Schroon Lake:

> Schroon Lake is undoubtedly one of the most popular semi-wilderness resorts in the country; it is surrounded on all sides by mountains, not high, but wild and rugged, and broken into curious fragmentary masses, growing smoother as you approach the north end.
>
> Approaching from Chestertown you catch the first glimpse of Schroon Lake, as you mount to the top of Landon Hill. From the summit of this a magnificent view is obtained of the far eastern ranges, the course of the Schroon toward the south, the Adirondacks to the west and north, the mountain hollow, where nestles the lovely lake, the naked rocky-sided ridges and knobs around west of its outlet and the deep valley almost at your feet.
>
> And when the summit is reached the view is finer than a great many that are attained only by an energetic scramble up a mountain path, and call forth paroxysms of ecstasy, simply because someone else has set the example, . . . one of the most pleasurable excursions imaginable for one who enjoys the miniature grandeur found in these outlying spurs of the Adirondacks, and the sweet bits of rock and form studies of the road-side. (*LGI* 1873, 161–62)

Stoddard says Schroon Lake attracts the best class in society "for the bright skies, the waving fields, the far reaching forests, and the great grand, freedom of the mountains," but he claims elsewhere that the most important site in the region for its scenic beauty and unique natural rock formations is Ausable Chasm. Stoddard says:

> The finest excursion trip now afforded is to the wonderful Ausable Chasm, the greatest natural curiosity in America, by way of Lakes George and Champlain, passing through the entire length of these two beautiful sheets of water by day-light. This affords one of the finest excursion trips for parties spending the summer at Saratoga and Lake George, as it requires but a very short time and gives an opportunity of visiting localities now fast becoming famous as the most romantic on the American Continent, and the whole trip being made through a part of the country unsurpassed in its endless variety of natural scenery. (*LGI* 1873, 175)

At the conclusion of the book are a number of advertisements for hotels in the various areas. Stoddard's illustrations accompany several of them, and it seems likely, owing to his writing style, that he added to the textual descriptions beyond the basic facts of prices, number of rooms, and so on. For example, the East Lake George House is described as follows:

> The luxuriant foliage, and beautiful tree and rock studies at this point, afford attraction to the artist; the quiet nature of the surroundings make it a suitable resort for those inclined to rest; excellent lake fishing affords the best of sport in that line, while the sweetest of country fare, with a determination on the part of the proprietor to leave nothing undone for the comfort of his guests, makes this a very desirable stopping place. (*LGI* 1873, 181) [8]

These passages from Stoddard's early *Lake George; Illustrated, A Book of To-Day* reflect an appreciation of wilderness and scenic beauty, but nothing particularly original. If anything, they represent the entrepreneurial spirit of the times in the marketing of the resort experience. But then, vacationers at Lake George did not think of themselves as surrounded by wilderness in the way that tourists to the Adirondack interior did. Stoddard's romantic descriptions of the landscape are similar to those of other popular writers of the period, for example, Edwin R. Wallace's *Descriptive Guide to the Adirondacks* revised in 1899. Stoddard's text remained virtually unchanged through later editions, except for updated hotel information. This lack of change was most likely acceptable to Stoddard because the book continued to be profitable and served as a means to advertise his photographs.

In 1874, Stoddard produced another guidebook, *The Adirondacks: Illustrated.* This volume, and its revised editions, is undoubtedly the best known of Stoddard's guidebooks and has been

8. Stoddard sent advertisement subscription forms to the hotel owners annually so the information for new editions could be updated. These forms, "Information Wanted for Stoddard's Guide Books," asked for changes of rates, accommodations, opening and closings of the season, transportation access, etc. and it is reasonable to assume Stoddard, with the hotel owner's concurrence, enhanced the advertisement's description.

reprinted as recently as 1983.[9] Between 1874 and 1892 the book included a narrative of his 1873 trip through the Adirondacks. In 1893, this narrative, which had been revised continually, was eliminated, and the volume took the form of a standard guidebook.

There were several title changes and descriptions over the various editions. The title of the first edition, *The Adirondacks, Illustrated by S. R. Stoddard, Author of* Ticonderoga, Lake George, Illustrated, *etc. Weed, Parson & Co., Printers. 1874. copyright by S. R. Stoddard 1874,* changed in 1880 when the following description was added: "Narrative of a trip through the wilderness, with description of the natural features of the region; hints concerning supplies and general outfit for camp and trail; cost and manner of reaching the various resorts, hotels, with capacity, price of board, etc., tables of elevations and distances, maps. etc., etc." (Stoddard 1880, 1). Beginning in 1893, Stoddard reduced the book to pocket-size and changed the description on the title page to: "Description of notable features of the region; forestry and its forest, their condition and needs; hints concerning fish and fishing, supplies and general outfit for camp and trail; cost and manner of reaching the various resorts; hotels, with capacity; price of board, etc.; tables of elevation and distances; maps, etc., etc." (*AI* 1893, 1). These changes in the description represent a transition in Stoddard's thinking about the Adirondack wilderness. His mention of the forest's "conditions and needs" is surely the result of his efforts on behalf of the "forever wild" movement.

As with *Lake George; Illustrated,* Stoddard sowed confusion over the numbering of his editions. He began numbering the editions in 1875. He called that edition the "3rd," though it appeared in the second year of publication. The next time an edition received a numerical designation was in 1881, with the "10th," which appeared in the eighth year of publication. As with *Lake*

9. The 1983 reprint of the 1874 edition was published by the Chapman Historical Museum of the Glens Falls–Queensbury Historical Association. The original imprint is S. R. Stoddard, *The Adirondacks: Illustrated* (Albany, N.Y.: Weed, Parsons, 1874).

George; Illustrated, Stoddard probably considered the paper and cloth editions of 1874 and 1875 as separate editions.

Beginning in 1874, Stoddard included his own engravings after his own design as well as those of others as accompaniments to the text. In 1888, the first photogravure illustration appeared, and by 1895 half of the illustrations were photographic images.

The first paragraphs of *The Adirondacks: Illustrated,* in Stoddard's purple prose, set the tone for the series.

> On wings of thought swifter than the lightnings's flash cleaving through space, we sweep across the drowsy earth, over smoke-polluted cities, sun-scorched meadows, burning plain and highways with their flaunting skirts of sand, nor rest until the fragrant odor of wild flowers and the dewy breath of forest trees come like incense wafted to us from below.
>
> Come with me up into a high mountain! I cannot show you "all the kingdoms of the world," but, "the glory of them." Over a rippling ocean of forests first, their long swelling waves, now rising, now sinking down to deep hollows, here in grand mountains, crested as with caps of foam, there tormented by counter currents into wildly dashing shapes, like ocean billows, frozen by Divine command, their summit-glittering granite, their deep green troughs, gleaming with threads of silver and bits of fallen sky.
>
> Now, the trees of the valley glide away behind us; the dark spruce and pine; and the sturdy balsam climbing the mountainside—tall and graceful at first, but growing smaller as they rise; now gnarled and twisted and scarce above the surface, sending their branches out close along the ground, their white tops bleached and ghastly, like dead roots of upturned tree, the hardy lichens still higher, then comes naked rock, and we stand on the wind-swept summit of the monarch of the Adirondacks, "Tahawas," the cloud-splitter of the Indian. (*AI* 1874, 1–2)

This overexcited prose is aimed at armchair travelers, and it presents a different image of the landscape than will his photographs. Stoddard adds to that image in the following description of the great peaks of the Adirondack when he writes:

> East, West, North, South, limitless, numberless, a confused mass of peaks and ridges, gathering, crowding close up to the base of the

one on which we stand, and receding in waves of deep, then tender green, all down through the scale of color to its blue and purple edge; pen cannot convey an idea of its sublimity, the pencil fails to even suggest the blended strength and delicacy of the scene. The rude laugh is hushed, the boisterous shout dies out on reverential lips, the body shrinks down, feeling its own littleness, the soul expands, and rising above the earth, claims kinship with its Creator, questioning not his existence. (*AI* 1874, 2)

Here Stoddard not only describes the landscape—he makes reference to a connection between it and a divine influence. This interrelationship is consistent with much of the thinking of the period, which casts the Almighty as the great designer of the landscape and considers it his pantheon.

Other passages of text in *The Adirondacks: Illustrated* exemplify the romantic language of the time. In describing Ausable Chasm, Stoddard writes:

Time came and went, long-ages rolled away and floods swept over the uneasy world that reeled and staggered under the pulsation of its mighty heart of fire; in places the thin shell bubbled up into mountain ridges, and breaking, cooled; then came the glacial period when the great ice-bergs passed across, grinding uplifted points to atoms, and, carrying huge boulders onward in their course, dropped them miles from where they were taken; then the waters fled away, the seams and cracks were filled with rich alluvium, holding in its bosom the germs of vegetable life that in time covered the world with a mantle of beauty. (*AI* 1874, 47)

In chapter 6, titled "On the Road" Stoddard portrays Wilmington Pass, the way leading to North Elba along the Ausable River:

It is one of the finest, if not *the* finest, combination of river, rock, and mountain scenery to be found in the Adirondacks, and was especially beautiful in its autumn dress, as we saw it on that early October day. The road ran along up by the river, fringed and canopied by the crimson and yellow maples, the great, ragged, rough-armed birches, the cone-shaped balsam, the dainty-limed tamarack and scarlet-berried mountain ash. (*AI* 1874, 64)

Stoddard offered the following description of Lower Saranac Lake, again from his 1873 trip:

It was a lovely morning—a little frosty to be sure, but not uncomfortable—and the sun came out soon, clear and warm, rising delicate wisps of mist from the surface of the water and making the snow-laden trees glitter with their millions of diamonds, and the naked summits of the high mountains—Whiteface on the northeast and March, with its surrounding peaks, away to the southeast—reflected in the glassy lake like great mountains of shining snow. (*AI* 1874, 84)

A final passage, demonstrating the romantic tone of Stoddard's prose, recounts the part of his 1873 trip on the Raquette River.

After dinner we followed the boat over the carry in its awful slushy, snowy muddiness, and putting it in above the rapids set out up the river once more. Here the water, that at a depth of two feet is a rich brown or red, appeared almost inky in its blackness. Sluggish in its motion, it seemed to fill the space left and fairly round in its center. Great dark green cedars line its banks, their reaching branches out toward the light downward thirstily toward the water, seeming in this to display their love for light and moisture, for the sides away from the river were naked and limbless. Here the river is four or five rods in width, and so still that when we passed up it seemed more like a river of black glass than water. It has slowly worn away the banks and undermined the cedars that line it until they have fallen over and stand at every conceivable angle with the surface of the stream, and as they have gradually fallen, the body, with its love for the zenith, toward the water, seemingly alarmed at their too near approach, turn upward and hang in great hooks and solid festoons from their leaning supports, the whole duplicated in the mirror below, seemingly made our journey lie through grand isles of gothic arches on either side, while we floated on a thin something that held us suspended midway between the heavens above and the heavens below.
(*AI* 1874, 95–96)

The text of these passages remained virtually unchanged through succeeding editions up until 1893, most likely because there was no real need for change, except for keeping the hotel and transportation information up-to-date. Besides, Stoddard may have viewed his prose as more than utilitarian guidebook description. He may have thought of it as literature.

A change occurred in the preface or "Greeting!" beginning in 1891. Stoddard added a new section on the preservation of the forests of the Adirondacks. That was a year before the issue of the "forever wild" legislation would come to a vote in the New York State Assembly. Stoddard presented his opinion on the subject in this introductory section:

The preservation of the forests is a question of vital importance not only to the Adirondack region itself but to the State and country as well. About one-third of the mountain and wilderness region is drained by the Hudson, the remainder by streams that run into the St. Lawrence and it is a curious fact that the section where the great Hudson River and its higher tributaries rise are less known to the public than almost any other part. It is also a fact that this section is being gradually stripped of its valuable trees far up into the rugged Indian Pass and around its wild head waters, except where an occasional narrow belt is left untouched around the more important lakes. All this section, with a good part of the western water-shed, should be under control of the State, and would be cheap at almost any price, *now*, before irreparable injury is done. How near that point has been reached cannot be determined yet, but the gradual annual shrinking in the water supply of the Hudson, with its sudden floods as sudden drying-up of tributary streams, are warnings that should not be ignored. The lumberman, engaged in an honorable (and profitable) business is not to be blamed for making what he can out of it. It is a pure matter of business with him as, with dynamite and giant powder, he clears away obstructions in mountain gorges and wilderness streams, and with dams, floods, and drains the valleys until the retiring waters leave behind them but decay and death. Following him comes the woodpulp fiend who strips the hills of the softer wood, which the lumberman has pointed to with pride as showing that *he* did not cut away the forests, until finally the "duff" which through ages past has slowly climbed the mountain sides affording support to the compensating vegetation that in turn deposits more duff higher up—opened to the sun becomes as tinder; then comes the fire, and after that the deluge. The legislature rises to the occasion by authorizing the purchase of wild land at the munificent rate of one dollar and fifty cents per acre. Meantime, the club man and the lumber man and the charcoal man and the woodpulp man and the man with a little

money to invest for a rise, and the little that falls back on the State comes after being robbed of that which alone makes its possession a thing to be desired. (*AI* 1891, vi–vii)

With this passage, in his widely distributed and popular guidebook, Stoddard drew attention to the issue of the preservation of forest land. This form of preservation literacy most assuredly had an impact on those who traveled to the Adirondacks for recreation, since it described the likely devastation of the natural resources they enjoyed and pointed to the State of New York as a yet impotent, but in the future powerful, player in the struggle between the forest's exploiters and preservers.

In the "Greeting" of the following year's edition, Stoddard made an impassioned plea for the passage of the impending legislation:

The State Park as proposed, incloses [*sic*] an area of about 4,000 square miles, and, while the state has acquired and holds with doubtful tenure within its limit, but about 800 square miles, 1,000 square miles are owned by lumbermen who make no apologies for following a legitimate business, and over 2,000 square miles by clubs and corporations set aside as reserved "for the preservation of the forests and the propagation of game and fish" and, of course, held for their owners' private use. To such ownership the public can have no reasonable object although the restrictions may prove unpleasant to individuals at times, but the public *has* a right to demand that the forests shall be preserved for the public good, whoever may own the land, and will fall short of a duty to coming generations if it fails to insist on that right.

A Law should be enacted prohibiting forever the cutting of an evergreen tree except with the approval of competent authority under the government, on any land in New York State lying 1,800 feet above tide. Then let the clubs and individuals struggle for the acreage to their heart's content. (*AI* 1892, viii)

The Adirondacks, Illustrated, with its editorials related to the protection of the Adirondack forests, coincided with Stoddard's efforts on the lecture circuit. These began around the time of the 1891 "Greeting." They anticipate *Stoddard's Northern Monthly*, a forum for the expression of environmental concerns, beginning in 1906. These "editorials" follow Stoddard's first full expression of

his concern for the future of Adirondack wilderness and water-ways, which is found in an article published in 1885 titled, "The Head-Waters of the Hudson," in the Adirondack periodical *Outing*. The year 1885 was the year the Forest Preserve was established by the State of New York. It was intended to protect the forest land but, being difficult to enforce, was largely ignored by the lumber industry. Two-thirds of Stoddard's article is devoted to romantic descriptions of the origins of the Hudson River; the remainder discusses the danger posed by destructive logging of the Adirondack forests and its effects on both the land and the Hudson and its tributaries. In describing the area, specifically Lake Tear of the Clouds (where the Hudson River rises) high on Mount Marcy, Stoddard writes:

> How wonderful the scene from the summit! How marvelous its colors! East, west, north, south, in grand procession come the mountains; countless, limitless; close up against their chief, stretching away into dim space; here marching in line like grim soldiers; there gathering in twos, in threes; in cluster; in constellations. You are at the centre of a vast, double concave of earth and sky, lifted upon a point that falls away on every side in down sweeping lines which rise again to your level, through all the varying shades of olive, blue, and purple to its distant wavering rim. A curious sense of motion pervades all nature. The stately hills seem circling slowly around in well-defined plains and orbits; you glance away over them, and the point on which you stand sinks with a never-ceasing motion. The eye drops down along the steep incline, and the mountain begins an upward motion, rising, rising, until you feel that you are nearing Heaven and lift your eyes to behold it, when, lo it has heights and depths never before imagined, a fathomless vault whose length and breadth passeth all comprehension. (HH 1885, 59–60)

Stoddard moves from this descriptive passage to the issue of preservation by juxtaposing the rights of individual exploiters and those of the public. He distinguishes between the scenic value of wilderness landscape and its greater significance for the public good with the following analogy:

Should some one, with all necessary and legal rights, attempt to blast away the rock which the Niagara pours, degrading this particular bit of nature's grandest work to make of it a sluice-way for the shunting of logs, two nations would rise in wrath to visit on the vandal deserved punishment; and yet, the injury would be nothing compared with that which is being done continually here [in the Adirondacks]; for, while the one would be a little more than a matter of sentiment, in the other is involved the question of health, of the perpetuity of a region of lifegiving aid and pure, never-failing water or its transformation into an arid flood-breeding waste. (HH 1885, 62)

With reference to the creation of dams for logging, Stoddard emphatically says, "there exists to-day hardly one important lake or stream in the Adirondacks that has not been tampered with, dammed in the name of soulless utility with a result fairly expressed by a different spelling of the word . . . The beautiful valley, once fair and sweet as Eden, has become a foul, malaria-breeding pit" (HH 1885, 63).

Stoddard concludes the article with an extraordinary passage extolling the beauty and importance of the Adirondack landscape:

Beyond all questions of utility or health the Adirondack wilderness possesses possibilities of development that entitle it to a place among the wonderlands of the earth. Its mountains are multiform, grand in outline, stately without being lifted above the line of enjoyable existence. There are no waste or inaccessible places, no miasmatic or malarial regions, save as the direct result of man's agency. There are depths into which cataracts thunder; where the sunshine never enters; where the ice never melts. There are cascades beautiful as a fairy's dream, valleys filled with waving verdure; sweet nooks like sunny nests hidden among the hills. There are waters clear as crystal; yellow as amber; brown as coffee; widespreading lakes that ripple softly on gold and silver sands; fields of star-gemmed lily-pads, where, shadowy and shy, the fierce trout lurks; shallows all alight with the soft glitter of little bright-scaled fishes. There are brooks that run down the brawling mountain steep; that dance over beds of rubies and opals. There are rivers that wind through dim aisles of arching green or stretch grandly across the wide domain,—a glistening wed of silver, knotted as

with pearls,—where the sunshine falls like a benison over all, and the aromatic breath of the forest fills one like a holy inspiration, bring purer thoughts and higher resolves, and leading upward to a nobler life. This is our heritage; shall our children have reason to say we were unworthy of the trust? (HH 1885, 63)

All that is what Stoddard asks his readers (and the state legislature) to preserve.

Stoddard combined the use of text and image in his very successful career as a lecturer. It is important to see how he used dual media to present his ideas and to alter the perceptions of his audiences about the Adirondack region and the need to preserve it. Stoddard began lecturing on the Adirondacks in 1891. In the years following, he developed his lectures to include his latest travels and photographs.[10] Stoddard's presentation, titled "The Adirondacks," which later was advertised as "Pictured Adirondacks," included a survey of various locales Stoddard had visited and photographed in 1873. He then traced the course of the Hudson River from its source on Mount Marcy to the Atlantic using nearly two hundred magic lantern images projected on a canvas. His accompanying narrative was described in an article entitled "A Glimpse of the Adirondacks" from the *Glens Falls Republican* of February 11, 1892, as the "painting of word pictures."

His presentation before the New York State Assembly on February 25, 1892, was a highlight of his career. It was organized and presided over by Townsend Cox, president of the New York State Forest Commission. The commission had campaigned vigorously for the Adirondack Park legislation. Stoddard's presentation was to

10. Stoddard had developed and packaged a number of lectures with titles including "America's Wonderlands," "The Sunny South," "Egypt," "The Land of Christ," and "Europe's Odd Corners." His New York agent, Major J. B. Pond, oversaw bookings of the lectures around New York State and as far west as Cincinnati, Ohio. An advertisement for a lecture on the Adirondacks in 1893 titled "Are You Going to The Adirondacks?" in addition to the standard description of hotels, scenery, etc. asks the question, "Are you in favor of preserving the forests? Do you know the danger that threatens them and the great Hudson River?" Stoddard clearly attempted to influence opinion on the subject, not only through his publications and lectures, but also in his promotional materials.

be of critical importance in the ongoing effort to influence not only
the general public, but the State legislature as well ("Seneca Ray
Stoddard's Lantern Show" 1992, 6). He apparently captivated the
audience with his narrative and the approximately 225 hand-tinted
lantern slides that he projected on the thirty-by-thirty-foot canvas
screen. According to a newspaper review of the presentation:

> The Assembly chamber last evening, instead of serving as a place
> wherein the laws of the State are conceived, was turned into an
> exhibition hall, and one of the best illustrated lectures ever given
> in the city by Prof. S. R. Stoddard of Glens Falls. Long before
> 8 o'clock every available seat was taken and many were standing.
> The fame of Prof. Stoddard and his wonderful collection of views
> of Adirondack scenery having preceded him, and called together
> the large audience.
>
> The lecture was primarily for the purpose of showing to the
> public that great and beautiful natural park to the north of us to
> the end that interests of the people might be awakened to the idea
> of protecting the forest and keeping it in its natural condition. ("A
> Tour on Canvass" 1892)

The article went on to describe the presentation:

> The lecturer, in beginning his lecture, caused to be thrown upon
> the canvas a map showing what he termed the "gateways" to the
> Adirondacks. He then took his hearers through each gateway, ex-
> plaining the principal points of interest along each route.
>
> Beginning with views of the Lake Champlain region, the lec-
> turer took his hearers into the Adirondacks for a most interesting
> trip, the mind's eye being materially assisted by the very vivid pic-
> tures of mountain lakes and scenes thrown upon the screen.
>
> The tourists were first taken to Saranac Lake, where among the
> other interesting views were those of the Adirondack Sanitarium
> showing patients wrapped up in furs on the verandas, the picture
> having been taken in January.
>
> The selfish policy of the lumbermen, who, by erecting a dam
> for mill purposes, flood a large level tract in what was originally
> one of the most beautiful valleys in the whole region, thereby cre-
> ating the so called "drowned lands" was dwelt upon at some
> length by the speaker.
>
> The lecturer then read a very credible original poem describing

the course of the Hudson River from its source, the little lake known as Tear of the Clouds, the most elevated body of water in the state, to the sea. The poem was illustrated by some of the finest views of the entire collection and included quite a number of local interest. ("A Tour on Canvass" 1892)

Until recently, the narrative text of the "Pictured Adirondacks" presentation was presumed lost, but what appears to be an annotated copy in Stoddard's hand is now in the collection of the Chapman Historical Museum in Glens Falls, N.Y. Unfortunately, the early stanzas of his poem, those related to the upper part of the Hudson and its source at Lake Tear of the Clouds, are missing. The extant verses follow the narrative of "The Head-Waters of the Hudson" article quite closely. One suspects the early verses of the poem resemble the article.

Stoddard began his "Pictured Adirondacks" presentation with "In the beginning God created the heaven and the earth." He took great liberties with his quotations from the Bible in his opening remarks, but he made a point of Divine creation and its relationship to the wilderness. Stoddard further introduced the subject with the early historical highlights of the region and concluded by saying:

> On its borders and at various points within are old settled sections considerable in the aggregate but like the spots on the sun small compared with the wilderness covered portions.
> The soil is unproductive. On the east is iron ore. In the interior lumbering is the chief industry and yet of chief importance to the native is the summer visitor. (*PA* 1892, 1)

He then projected a map of the Adirondacks and proceeded to describe specific locations: Lake George, Ausable Chasm, Saranac Lake, etc. He retold anecdotes of legendary Adirondack figures including Old Mountain Phelps and Alvah Dunning. Stoddard described a number of the hotels in the region as well as the resourcefulness of guides for camping and exploring the wilderness. He gave particular attention to sportsmen with interest in hunting and fishing.

The second part of his presentation, his poem tracing the jour-

ney down the Hudson River from its source to New York City, in-
cluded these lines from the latter half of the poem:

> *Close the mountains press the river*
> *In its journey through the Highlands.*
> *At the west, stern and forbidding,*
> *Storm King lifts his riven summit.*
> *Past the concave of the valley,*
> *Sloping southward from the river,*
> *Rise the heights of rugged Cro' Nest.*
> *Breakneck, scarred like any veteran*
> *Cuts the sky against the sunrise*
> *While Mount Taurus, heavy favored,*
> *Stands with round and massive shoulders*
> *Guarding well the little hamlet,*
> *Smoke-draped, at his feet reposing.*
>
> (PA 1892, 21)

Stoddard's mixture of fact, fiction, humor, and visual images de-
lighted and enlightened his audience, and his editorial stance in fa-
vor of preservation was strengthened accordingly. His final major
publishing venture was *Stoddard's Northern Monthly.* It was un-
successful as a business proposition but clearly was influential in
raising awareness of environmental issues affecting the Adiron-
dacks during the period of its publication. It is important to un-
derstand the publishing environment into which Stoddard's
periodical emerged.

In 1898, *Woods and Waters* appeared, a periodical devoted to
advancing the interests of the region. Its publisher, Harry V. Rad-
ford of New York City, oversaw the thriving publication and its va-
riety of articles and features. It had almost 20,000 subscribers.
Nearly half of each issue was dedicated to advertising, the re-
mainder to articles on Adirondack and other subjects. Radford pro-
moted issues related to wildlife, including seasonal limits on the
hunting of black bears and increasing the populations of certain
animals that had become virtually extinct in the region, such as
the beaver. In 1905, Radford ceased publishing to pursue interests
in hunting and exploration. Another publication, *Forest Leaves,*

began in 1903, was published by Sister Mary Kieran and was "written by friends of the Adirondacks to be read by friends of the Adirondacks." A number of writers, including Radford, William H. H. Murray, and Stoddard, were contributors. The publication enjoyed a wide readership until it ceased publication in 1934 (DeSormo 1972, 141–42). Within this context, Stoddard initiated his new periodical. However, the idea of publishing a periodical seems to have been in Stoddard's mind from a few years before. A mock-up of a proposed periodical is in the collection of the Chapman Historical Museum in Glens Falls. The title of the magazine was to be *Egoland, An Illustrated Magazine of Travel, Truth and Fiction.* It was to be issued quarterly beginning in mid-1900. According to its "Plan and Promise," it was "To show the beauties of our land in line and color. To do as good work as we can. To make every advertisement a work of art. To print only clean articles—signed by the author. To give credit where due. To do as we would be done by. To give five cent's worth for a Nickel" (*Ego*). In the design of this first issue, the lead article, only a paragraph in the mock-up, is entitled "The Hill Country" and reads as follows:

> "A Dream of Beauty" said Wallace Bruce the poet, when first he saw the "Pictured Adirondacks." If simple line and halting color on canvas can call forth enthusiastic words of praise from the world-wide traveller, what thoughts must come when the mountains themselves in all their glory stand revealed. (*Ego*)

Passages such as this one and others suggest a magazine devoted primarily to the appreciation of the Adirondack landscape reminiscent of Stoddard's earlier work such as *The Adirondacks: Illustrated.* If that was the focus of the publication, it seems out of place considering the other changes that had developed in Stoddard's writing, specifically related to the protection of the Adirondack land and waterways. *Egoland* was never published. Perhaps the timing and market competition made its publication unrealistic. Nevertheless, Stoddard persevered, and half a dozen years later his idea of publishing a periodical, though one with a somewhat different editorial emphasis, became a reality.

As a Writer

Stoddard's Northern Monthly was published from May 1906 through September 1908 with twenty-eight issues in all. The title changed to *Stoddard's Northern Monthly: The Pocket Story Book* in May 1907 when he reduced the physical format as the title suggests. Unable to enlist enough subscribers to support the publication, Stoddard discontinued it in September 1908, having returned the title to its original wording two issues previously. Although short-lived, it served as a platform for Stoddard to address issues of the region about which he felt passionately. The foreword in the first issue stated his intent:

> The fundamental policy of the *Northern Monthly* will be the gathering and preservation of unrecorded stories and traditions of the Great North Woods; to picture with pen and camera the glories of its mountains and valleys; to present their worthy features, and in legitimate ways to advance the interests of Northern New York. Illustrations will be given lavishly, for pictures talk, and the camera cannot tell a lie.
>
> The effort will be made to get at the truth concerning unsettled questions affecting the welfare of place and people and present it for consideration.
>
> The public domain is being despoiled and the rights of coming generations jeopardized for private gain. Do the people realize this?
>
> The little thieves are being punished and the big ones presented with bouquets. Why?
>
> If you have a word to say for the public good, a good story of hunting and fishing, or a tradition that is worth preserving, send it in. The invitation is for all who mean well. (*SNM* 1907)

With the change of title in the second year of the publication, Stoddard described what he saw as "for the good of the Adirondacks" in the following five points:

> 1. I am thoroughly in favor of storage reservoirs for regulating the flow of the Hudson, but they should be outside the State Park and no opportunity given for the destruction of the forests in the construction of dams therefore.
>
> 2. I would have a law to prohibit the cutting of trees on land drained by the Hudson River one thousand feet above tide, regard-

less of ownership. If any man were injured thereby, the State could well afford to pay the value of the trees left standing.

3. I would have the State control absolutely to the rim the Hudson River watershed in the interests of the people of the cities along its course who must soon look to the mountains for water to drink. It is immaterial who owns the land so long as the wood and waters are preserved under inviolable laws.

4. I would have the State control all the underdeveloped water power along the Hudson's tributaries in the interests of equity and charge customers a fair price based on the cost of construction and maintenance. It should not come into competition with private interests except to the extent from preventing a monopoly which might withhold from small consumers the opportunity to obtain power at a fair price. It should deprive established interests of acquired rights on land or in the ordinary flow of the river, but could justly make consumers with water power of their own pay a fair portion for water furnished in excess of the ordinary flow in times of scarcity.

5. Preservation of the forests as a matter of sentiment recognizes no boundaries, but from a utilitarian point of view the territory drained by the Hudson River is of infinitely greater value to the State and to the world at large than all other Adirondack territory whose waters run in other directions. (SNM 1907)

In this spirit, Stoddard wrote a number of articles for the periodical over the next several years, championing a variety of ideas with the protection of the Adirondack wilderness as their common focus. He continued his efforts on behalf of protecting the Hudson River and said it was "unquestionably good business to save the water, but where business and public welfare are opposed, business should be held of secondary importance" (SNM 1906). He followed several months later with an impassioned article, "The Rape of the Mountains," in which he called for strict state government control of the lands adjacent to the head-waters of the Hudson regardless of state or private ownership (SNM 1907, 5–9). Stoddard asserted that he was not opposed to "cutting of a single tree on sentimental grounds, but I am opposed to the policy of

releasing to private parties a right to flood public lands and the construction of dams therefore" (SNM 1907, 9). Although there were a number of articles describing the beauty of the Adirondack wilderness, the general tone of the periodical was one of activism on behalf of the region and its landscape.

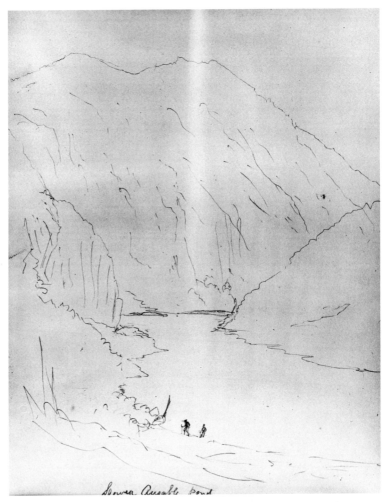

Lower Ausable Pond

13. *Lower Ausable Pond*, 1873. Graphite on paper, 6½ x 8¼ inches,
Courtesy of The Adirondack Museum.

3 Seneca Ray Stoddard as a Photographer

The other significant part of Stoddard's career is his graphic work. That work comprised a substantial number of drawings, engravings, and paintings and (and of much greater importance) photographs. It is important to understand all of his graphic work to comprehend the relationship he established between text and image and the impact that this graphic work had on the concept of wilderness.

As noted earlier, Stoddard began his graphic career as a sign painter in 1862. By 1867 he termed himself a landscape photographer. Although he is best known as the latter, his work as a draughtsman and painter continued from the beginning of his career well into his later years. Some of the images he produced both manually and photomechanically in this work, and the changes that occurred in it, became integral parts of the texts he published.

Some of the earliest examples of Stoddard's drawing can be found in the sketchbooks now in the collections of the Adirondack Museum.[1] The drawings document his early trips and were most likely preparatory sketches for oil paintings that he executed in his studio. A number of the drawings have written descriptions on them noting colors such as "yellowish" or "purple glow," memoranda for this purpose. Stoddard included human figures in some of the drawings, but his rendering of them was awkward. He may

1. The Adirondack Museum has five Stoddard sketchbooks dating from 1866 to 1873, each containing from nine to twenty-seven pencil drawings. The earlier drawings record sites around Glens Falls, and the later (1873) document his trip with his brother-in-law, Charles Oblenis, through the heart of the Adirondacks.

have included them mainly to provide scale for the landscape, but may also have been following a convention already well established in nineteenth-century American landscape painting, which depicted individuals as part of and appreciating the landscape. Many of the drawings are quite delicate and fresh. Two examples from the 1873 trip are "Lower Ausable Pond" (fig. 13) and "Blue Mountain Lake, October 11, 1873" (fig. 14). In their simplicity these drawings seem to have no purpose other than to depict the beauty and pristine nature of the Adirondack wilderness. The pencil sketch titled "Long Lake South, October 4th, 1870" (fig. 15) is from Stoddard's first trip into the Adirondacks.

Through the 1870s and 1880s, Stoddard continued to make pencil sketches and pen and ink drawings, but these works did not

14. *Blue Mountain Lake, October 11, 1873.* Graphite on paper, 6½ x 8¼ inches. Courtesy of The Adirondack Museum.

As a Photographer

15. *Long Lake South, October 4th, 1870.* Graphite on paper, 4½ x 6¾ inches. Courtesy of The Adirondack Museum.

reach the public. Only those images reproduced as wood engravings in early editions of *Lake George; Illustrated* and *The Adirondacks: Illustrated* found an audience and need to be examined in relation to his texts. The early published images were wood engravings based either on photographs or on drawings made for that purpose. In some instances, a wood engraving was a combination of both. A number of examples in each category demonstrate Stoddard's frequent use and reuse of the images.

Stoddard often combined an engraving with text, for example, on the first page of the introduction to *Lake George; Illustrated* (fig. 16). The initial word of the introduction is the article "A", Stoddard extends the cross of the letter to form a branch on which an owl is perched. This pictorial letter has foliage trailing from it, and the paragraph is indented to accommodate the drawing. This indentation highlights the interconnectedness of the text and im-

75

STRONG conviction of duty, a laudable desire to give information, and a philanthropic willingness to contribute something, in shape of advice, to a long suffering people, coupled with the known fact that the public demand some source wherefrom can be drawn, as from a living fountain, supplies of knowledge, has induced the author, in a fit of temporary insanity, to attempt the semi-literary feat of perpetrating a guide book.

I shall endeavor to write of Lake George as it appears to me, giving my impressions of things in general, "with malice toward none, with charity for all," and if I err in judgment, if I either wrong or unduly extoll the virtues of any person, place

16. Introduction, *Lake George; Illustrated,* 1873, p 3.

FF for Lake George! How the heart bounds and the pulse quickens at the very sound of the words that bring with them thoughts of the holy lake. In fancy we once again breathe the air, heavy with the odor of pines and cedar, or fragrant with the breath of blossoming clover..

Again we wander among the daisies and buttercups that gem the hillside, sloping so gently down to where the wavelets kiss the white beach, or floating among the verdant islands watch the sunlight and shadows chase each other up the mountain side, while every crag and fleecy cloud is mirrored in the quiet waters below.

17. *Lake George; Illustrated,* 1873, p. 6.

OME ISLAND claims our attention as being the highest in the lake. Seen from the north and south, it has the appearance of a huge dome, somewhat flattened, but having enough of the appearance to justify the name. It is about nine miles, from Caldwell in a straight line.

Following along on the western shore we see a group of three islands, known as " The Brothers ;" then farther north, and separated from the main land by a narrow strip of water, is Clay Island, owned by Rev. G. W. Clow, of Hudson, who, during his summer vacation, may often be seen swinging the axe or piling brush as energetically as the most enthusiastic votary of muscular christianity could desire.

18. *Lake George; Illustrated,* 1873, p. 70.

age. Similar images can be found on the initial pages of the sections on Lake George (fig. 17) and Dome Island (fig. 18). The former incorporates an "O" from a natural scene in the wilderness as the first letter of the sentence; the latter "D" depicts the island scene that the text describes. Some of these images are possibly original engravings by Stoddard, while others are copied from Stoddard photographs engraved by others, with the name of an individual engraver or engraving firm as part of the image.

Many of the images of wilderness settings contain a single tree that dominates the foreground and provides a frame for the entire image. The result is variety in the layout of the image and the text. For example, the description of Deer's Leap Mountain from *Lake George; Illustrated* (fig. 19) delicately incorporates the text and engraving of the mountain meeting the water, dramatically framed on the left and through the center by a single tree and its branches.

100 LAKE GEORGE.

Deer's Leap Mountain is on the west, a little in advance; the top is rounded; the side facing the lake a perpendicular wall of rock, which gives back a magnificent echo when called upon so to do. At its foot are great frag-ments of rock that have fallen from time to time, and said to be a favorite resort of the rattlesnake. Once on a time a buck, pursued by hunters, was driven to the brow of the precipice, with a yelling pack of hounds close at his heels.

" Not the least obeisance made he;
Not a minute stopped or stayed he—"

but leaping fearlessly, far out over the giddy height, was impaled on the sharp point of a tree below.

THE DEER'S LEAP.

19. *Lake George; Illustrated*, 1873, p. 100.

NORTHWARD.

HE Delaware & Hudson Canal Company is one of the oldest and wealthiest corporations in the country. From the coal field of Pennsylvania, where it was organized, and where they ran the first locomotive used on the continent, it has reached out and absorbed the smaller fry until now it stands in the front rank among carriers, the hand at Albany grasping the strong reins of the Albany and Susquehanna to the south and west, and the Rensselaer & Saratoga toward the north, with the various divisions and connections, and handling them in the most artistic manner possible.

20. *Lake George; Illustrated*, 1873, p. 146.

Other examples of combining the first letter of a word in the text with a natural background of a single tree or foliage can be found at the beginning of a number of sections (fig. 20). These appear to be mechanically produced from stock type (and not by Stoddard's hand) or reproduced from one of his photographic images.

An image that first appeared in print in *Lake George; Illustrated.* was that of Stoddard's logo (fig. 21), which is perhaps of more interest biographically and in terms of Stoddard's influence than as a contribution to the transition of the concept of wilderness, but it is noteworthy nonetheless. The image originally appeared as the logo on Stoddard's racing canoe, and a narrative description and the logo itself are found in the first edition of *Lake*

THE WANDERER.

21. *Lake George; Illustrated*, 1873, p. 85.

George; Illustrated. Stoddard in his canoe on Lake George is described as follows:

> Well, that's Stoddard, the photographer, and that's his boat, the *Wanderer*. He wanders around all over the lake, taking views and money. Notice that picture on his sail, looking more like cancer in the old-fashioned almanac than any thing else I can think of? Well, he calls that his "coat of arms"—legs would be more appropriate—and it is supposed to be himself astride of a camera (his hobby) in pursuit of wealth, there represented by a fat-looking money bag with wings, to show the nature of the game which he hopes to bring down by aid of his lance, that being, as he also claims to be an artist, a mahl stick. Now, heraldry is all right when it's plain enough to be understood; but everybody who sees that says "Shoo fly!" thinking his little bit of sentiment intended for a joke—a good joke on him, I think. (*LGI* 1873, 86)

22. *Logo*, n.d. Wood engraving, 7½ inches. Courtesy of The Chapman Historical Museum.

23. *Ausable Pond,* 1874. Engraving from a photograph.
Frontispiece, *The Adirondacks: Illustrated.*

Edward Comstock points out that by 1879, the logo has been modified to include an oversize quill to replace the lance (fig. 22), thus suggesting Stoddard's increasing reputation as a writer. A third version of the logo appeared on the paperback edition of *The Adirondacks: Illustrated* in 1888. Stoddard, still riding aboard his camera, has the flying money bag firmly skewered by the quill, suggesting that his writing had secured financial success. Comstock concludes by saying "Photographers, like witches on broomsticks, have magical powers" (Comstock 1986, 172).

Stoddard employed similar wood engravings, either after his drawings or his photographs, through the successive editions of *The Adirondacks, Illustrated.* The frontispiece of the guidebook is an engraving undoubtedly based on a photograph by Stoddard and engraved for the publication by someone else (fig. 23). The image of Ausable Pond is similar to a number of Stoddard photographs of the same location. There are four full-page engraved illustrations clearly based on photographs and a number of portrait engravings, again based on photographs. It was not until 1888 that the first actual photograph appeared in the guidebook in the form of a railroad advertisement, and it was the mid-1890s before of photogravures were routinely included.

Engravings based on Stoddard's photographic images were used in some of the most popular American periodicals of the nineteenth century. It is not clear if Stoddard gave his permission to reproduce the images or if they were simply pirated, as was common before strict copyright laws. Two publications, *Harper's Weekly* and *Frank Leslie's Illustrated Newspaper,* featured articles on the Adirondacks with engravings after Stoddard's images.[2] Inclusion in the popular press of images depicting the beauty of the Adirondacks reinforced the perceptions tourists had of the region.

Although Stoddard had painted both portraits and landscapes early in his career, few examples of the portraits are documented,

2. "Among the Balsams," in *Harper's Weekly* 32 (Aug. 11, 1888), 597. and "Adirondack Woods, Waters, and Camps," *Frank Leslie's Illustrated Newspaper* (Aug. 13, 1887), 417.

24. *The Narrows, Lake George,* c. 1870s. Oil on board, 8½ x 13½ inches. Courtesy of The Adirondack Museum.

but several dozen landscape paintings survive, most of them now in the collection of the Adirondack Museum (Crowley 1981, 2). Stoddard's paintings demonstrate a lack of technical skill compared with the work of academy-trained landscape painters of his day. They are important, however, as records of the changing perceptions of the Adirondack landscape. Several examples are worth examining. Most are oil on board or canvas, with dimensions ranging from several inches up to approximately three feet. One suspects all that the painted images are based on either pencil sketches or photographs. *The Narrows, Lake George* (fig. 24), thought to be from the early 1870s, certainly comes from Stoddard's travels. Although this painting and his others are not highly developed in comparison to others of the period, they are representative of the tranquility and beauty of the landscape. In contrast is a picture from later in Stoddard's career entitled *In the Drowned Lands of the Raquette River* in the collection of the Adirondack Museum (fig. 25). The painting is believed to have

been produced around 1888, corresponding to photographs Stoddard made at about the same time. What distinguishes the picture, aside from its monochrome palette, is the barren nature of the image and how the tree extends beyond the top and bottom of the picture frame. Mandel suggests this "invasion of conventional realistic representation" is similar to the way medieval illuminators portrayed the first letter in their text as a work of art (Mandel 1990, 112). As seen earlier, Stoddard used a similar technique to incorporate images and text in a variety of ways. But what seems most significant is the departure from the beautiful landscape to a depiction of the endangered landscape resulting from flooding associated with dams and deforestation. This picture gives the viewer a very different perception of the Adirondacks from that of the earlier paintings.

Stoddard was indeed a prolific photographer, having made thousands of images and reproduced and sold tens of thousands of

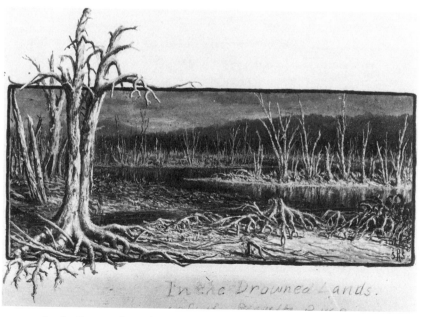

25. *In the Drowned Lands of the Raquette River*, c. 1888. Monochrome oil on board, 6 x 8 inches. Courtesy of The Adirondack Museum.

prints of those images. By 1876 he offered "2000 different views" (*AI* 1876, endpaper) of the Adirondack region. The Adirondack Museum has approximately five thousand distinct views. The Chapman Historical Museum has an estimated seven thousand photographs; many of these are duplicate images of the Adirondack Museum collection. Stoddard's technique changed as technological advances in the photographic medium developed, and it is useful to understand those changes.

Stoddard began his photographic career in the period when the wet-collodion negative process had been established following the first photographic process, the daguerreotype. The latter process was cumbersome, with the use of silver-coated copper plates and exposure times of three to eight minutes often resulting in unsatisfactory images, particularly if the subject moved. The daguerrean process was a direct positive process, which meant only single images could be produced and thus multiple copies could not be made and sold. The collodion process involved a mixture of nitric and sulfuric acids dried into ordinary cotton and was sold commercially. This "gun cotton" was dissolved with alcohol, ether, and potassium iodide and was poured over clean glass plates as the first step. When the collodion had set but was not dry, the plate would be sensitized by bathing it in a solution of silver nitrate, which resulted in a light-sensitive silver iodide. The plate—in a holder and still wet—was placed in the camera for exposure. It was subsequently developed in a solution of pyrogallic and acetic acids. When a final coat of protective varnish was applied, the plate was then ready to be used to make multiple prints. Some of this process required darkness, and therefore the photographers needed to take dark tents or wagons, along with all the chemicals, into the field (Baldwin 1991, 27–28). One can appreciate the work involved and why many photographers did only studio work, primarily portraiture.

By the early 1880s, Stoddard and others had adopted the "dry-plate" technique, which involved a thin glass plate coated with gelatin containing light-sensitive silver salts. These commercially

available plates had the advantage of remaining photosensitive over a long period of time, before and after the exposure, although some photographers continued to coat their own plates (Booth and Weinstein 1977, 7, 208). Stoddard also used albumen-coated paper, which had a smooth surface, the pores of the paper having been filled by the egg white. After examining many Stoddard photographs, one can conclude that he most likely toned some of the prints with gold chloride, which enriched the color and added to their permanence.

Another type of print produced by Stoddard was referred to as an artotype, which is in effect a collotype, a photolithographic process in which glass plates replace the lithograph stone as the surface to be printed. The glass plate is doubly coated with a gelatin of sodium silicate and potassium and is dried in a darkened oven at low heat. The plate is then exposed to light under a negative (contact printed) of a particular image. The plate is washed and dried and then carefully rolled with ink and printed on paper. The result is an image with very subtle gray tones and the appearance of having continuous tone (Baldwin 1991, 29–30).

In an article in the *Philadelphia Photographer* in 1877, which had been requested by the editor, Stoddard described how he prepared the glass plates and the collodion he used. The various "ingredients" resemble those previously described. He went on to discuss his camera and lenses. With regard to his preference for a camera, he noted the "Z Success" camera manufactured by E. & H. T. Anthony of New York for stereoscopic work, with a five-by-eight-inch glass plate for single-plate images or stereo views. He suggested that it is light, compact, and durable. As for lenses, he carried four pairs, ranging in size from 2 1/2 to 10 inches for stereoscopic work and a 10-inch "Morrison" for single views. He described his interest in long-focus lenses, "as wide angles fill the foreground with unimportant objects, and dwarf stately mountains down to insignificant lines" (LAP 1877, 146). In a description of his technique and equipment for landscapes he wrote:

I prefer single (achromatic) lenses, as the slight curvature at the margin is ordinarily of no account, and more than compensated for by the greater sharpness and detail obtained. They are also (when perfectly clean) free from a trouble which sometimes goes with the very best of combination lenses, a centralization of light, and a fuzziness at the edges where a dark object is brought against a strong light. Some of my best work has been produced with a pair of object-glasses taken from an ordinary opera glass (3 inch focus), mounted in rigid settings, and properly diaphragmed in front; of the same nature in the "E. A." (Anthony) lens, 10 inch focus, and an intermediate size of the same make. (LAP 1877, 146–47)

Stoddard went on to describe the type of tripod used, traveling with his equipment, and the use of assistants. In addition to his brother-in-law, Charles Oblenis, to whom he gave credit for his skill and careful manipulation in developing the photographs, he also employed youngsters to carry the plates from the camera to the "dark-box" in which they were developed. Stoddard found it tiring to carry the plates back and forth between where the photographs were taken and where they would be developed. By having assistance, he was able to keep "a clear, cool head at work all the time."

By 1884, the Eastman Dry Plate Co., later known as Eastman Kodak, offered rolled film and, in 1888, its popular Number One Kodak Camera. The latter came loaded with one hundred exposures, and one returned the camera and film together for processing; the camera was then returned with fresh film and the exposed photographs (Gilborn 1994, 1). As Stoddard became a distributor for Eastman Kodak, he surely used their products, including the film developing.

Stoddard is not unique among photographers in creating and then not adhering to a system, which makes the task of dating specific images nearly impossible. Many, but not all, of Stoddard's prints have a number on them, which was generally applied as a label either on the actual print or on the negative. Many of the numbers were used several times, on occasion for different subjects, but more often for slightly different views of the same subject.

Numbers in series initially suggested a geographic location, for ex-
ample a trip from Raquette Lake to Blue Mountain Lake, but later
images may have been replaced in the series with no real indica-
tion that they are later photographs. As a result, thematic dating
based on his various travels seems to be the most realistic, if not
precise, method for determining time periods. Stoddard applied for
copyright not only of his publications, but of individual images.
However, a thorough review of the U.S. copyright records indi-
cates some of the same problems with attempting to provide ac-
curate dates. Stoddard sought copyright years after the images
were made and often for large groups of photographs, which adds
to the complexity of establishing dates.

The earliest photographic images of the Adirondack wilderness
were made by William James Stillman, the Boston writer and
artist, in the late 1850s. Stillman, dissatisfied with commercial
and urban life, sought the Adirondack wilderness to restore his
soul, but he did not find the refuge he sought. In describing the in-
dividuals he met in the Adirondacks, he said, "My quest was an il-
lusion. The humanity of the backwoods was on a lower level than
that of a New England village—more material if less worldly; the
men got intoxicated, and some of the women—nothing less like an
apostle could I have found in the streets of New York" (Stillman
1901, 199–200). His artistic images reflect the scenic beauty in a
refuge from the distractions of civilization. It is in this immediate
photographic tradition that Stoddard began his own photographic
career.

Stoddard probably took his first photographs of the villages of
Glens Falls and Saratoga Springs, landscapes along the lower eleva-
tions of the Adirondacks and around Lake George, Lake Champlain,
and Fort Ticonderoga. Stoddard's first trip into the Adirondacks
proper in 1870 resulted in pen and pencil sketches, but no pho-
tographs from this trip have been identified.

Stoddard's second trip to the Adirondacks, and his subsequent
ones annually from 1873 through 1879, documented the idyllic
wilderness, scenic panoramas of mountains and lakes, and sub-

jects provided by the emerging tourist industry—the hotels and their guests and the various modes of transportation to the region. William Crowley describes these photographs from Stoddard's early career as follows:

> Several generations of vacationers are shown hunting, camping, fishing, boating, and hiking in the Adirondacks. A perusal of his images allows us to follow these people throughout their trips to the area: we travel with them on the steamboats, railroads, and stagecoaches that brought them to the mountains, we see the elegant hotels and humble boarding houses in which they stayed. The observer joins them around the campfire and sees the magnificent vistas of the mountains and lakes that drew them to the area. (Crowley 1981–82, 4)

In addition, during this period Stoddard photographed lumbermen, guides, and inn keepers as well as patrons from whom he received a number of commissions to document their business enterprises (railroads) or the homes they built.

The landscape in and around Ausable Chasm was a site that Stoddard recorded dozens of times in this early period. In describing his photographs of this scenic subject, he boasted that:

> Modesty is becoming, and may be indulged in with impunity, so long as it harms no one, and does not interfere with business. Relying on the good taste and honesty of connoisseurs, as well as my own judgment, I can and do say that I have the best photographic views of Ausable Chasm ever offered for sale, and am willing again to submit them with others to competent judges, who shall decide on their relative merits. (AI 1874, 200)

Even though few others had photographed Ausable Chasm at this point, Stoddard's not-so-modest assessment of his own work is accurate. The images have a remarkable clarity and drama about them. The image *Ausable Chasm—Split Rock* (fig. 26) is taken from a low vantage point looking up to include the vegetation growing atop the sides of the chasm and the clouds in the partially exposed sky. The trees on the right form a silhouette against the background sky. Another image of Ausable Chasm is *Ausable Chasm, The Long Gallery* (fig. 27), the path leading through the

26. *Ausable Chasm—Split Rock*, c. 1870s. Photograph, 4¼ x 7¼ inches, SRS no. 383. Courtesy of The Adirondack Museum.

27. *Ausable Chasm, The Long Gallery.* c. 1870s. Photograph, 4¼ x 7¼ inches, SRS no. 368. Courtesy of The Adrirondack Museum.

28. *Ausable Chasm, Running the Rapids,* c. 1870s. Photograph, 4¼ x 7¼ inches, SRS no. 414. Courtesy of The Adirondack Museum.

chasm. The photograph is constructed to have its focus on the path with the railing through the center of the image. A spectator leans on the railing admiring the view of the beautiful natural setting. The viewer of the photograph is presented with a sense of awe of the natural setting. A final image of Ausable Chasm, reproduced many times and entitled *Ausable Chasm, Running the Rapids* (fig. 28), presents the foreground of the river, with a boat approaching the rapids in the middle ground. The dramatic rock formations on the right of the image are contrasted with trees and vegetation on the left. The excitement and enjoyment of the scene, as well as its natural beauty, are evident to the viewer. All of these images reflect the sublime beauty and pleasure of the natural landscape.

The images Stoddard produced of the various modes of transportation into and through the Adirondacks served not only to document but also to encourage potential tourists. *The Adirondacks: Illustrated* included distance tables, routes, time tables, fares to different points, and maps. In addition to the factual information, Stoddard provided many photographs of the railroads, steamboats, and stagecoaches, which met both trains and boats at their destinations. A photograph such as *Adirondack RR Bridge across the Sacondaga* (fig. 29), which is typical of images Stoddard may have been commissioned to make for the railroad companies, also depicted the scenic beauty of the region. Two photographs illustrating steamboats—*Steamer "Stella," Raquette Lake* (fig. 30) and *Bridge at Outlet of Blue Mountain Lake* (fig. 31)—are but two examples depicting this type of transportation amidst the natural landscape. One of Stoddard's "composite views," titled *On the Plank, Half Way House, Bloody Pond, Ft. George Hotel* (fig. 32) includes several images of horse-drawn coaches. All of these images inform the viewer of the possible means of traveling through the Adirondacks, but they also helped create the perception of adventure that awaited the tourist in the wilderness.

Beginning in the 1850s, stagecoach inns and boarding houses for tourists became hotels, and by the late 1860s and early 1870s they were a thriving industry. Stoddard photographed the hotels and

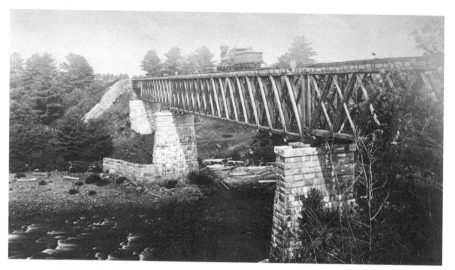

29. *Adirondack RR Bridge across the Sacondaga,* c. 1870s. Photograph, 4¼ x 7¼ inches, SRS no. 639. Courtesy of The Adirondack Museum.

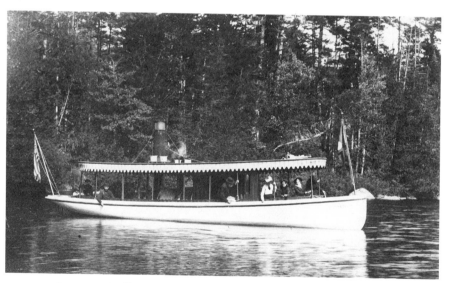

30. *Steamer "Stella," Raquette Lake,* c. 1870s. Photograph, 4¼ x 7¼ inches, SRS no. 728. Courtesy of The Adirondack Museum.

31. *Bridge at Outlet of Blue Mountain Lake,* c. 1889. Photograph, 4¼ x 7¼ inches, SRS no. 724. Courtesy of The Adirondack Museum.

32. *On the Plank, Half Way House, Bloody Pond, Ft. George Hotel,* c. 1870s. Composite photograph, 4½ x 9 inches. Courtesy of The Chapman Historical Museum.

their proprietors and guests. He did it for several reasons. His images were used first as engravings to accompany advertisements in publications such as *The Adirondacks: Illustrated.* The hotels then became a prime distribution point, initially for his stereoscopic views and then for single-plate photographs. The hotel owners needed favorable publicity, which Stoddard provided through his advertising; Stoddard needed a commercial outlet for his work, and hotel lobbies provided his primary audience for purchasing souvenirs of their Adirondack holiday. Stoddard also produced photographs that were used in another form of advertising, the illustrated brochure, describing the hotel, its rates, and how to get there. For example, the brochure for The Hemlocks, in Raquette Lake, printed with a simulated birchbark cover, includes a number of interior and exterior views of the hotel and its immediate environs.

Photographs of several of the important hotels warrant close attention. Stoddard photographed and continued to write about and advertise some of the hotels popularized by Murray in his chapters on hotels. Bartlett's (fig. 33), located in a beautiful, remote setting on Upper Saranac Lake, was one of early hotels to attract the tourist trade. Another popular hotel, known for its owner and proprietor, was Paul Smith's Hotel on St. Regis Lake (fig. 34). Paul Smith, born Appolos Smith, was a Vermonter of giant physical proportions as well as reputation. He was charming and easily made friends with his important and wealthy guests, but he could either accept or reject guests for his own reasons. As a result of Smith's personality (and his wife's ability to cook), the hotel was highly successful (Kaiser 1982, 47–48).

One of the largest hotels in America at the time was the Prospect House on Blue Mountain Lake. The hotel, built by Frederick C. Durant in 1879, could accommodate five hundred guests in what were state-of-the-art accommodations in terms of heating and plumbing, including electric lights in each guest room (Hochschild 1962b, 25–42). Durant's uncle was Thomas C. Durant and his cousin was William West Durant. Among those photographing Prospect House

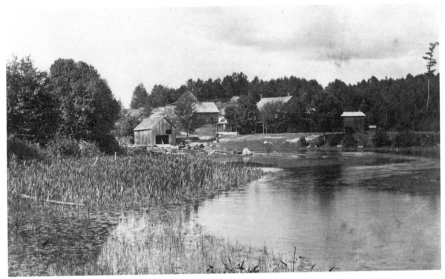

33. *Bartlett's, Saranac Lake,* c. 1870s. Photograph, 5 x 9 inches, SRS no. 536. Courtesy of The Adirondack Museum.

was Edward Bierstadt, brother of Albert Bierstadt. Stoddard photographed it extensively. Three images are representative of those he made. *Prospect House Landing, Blue Mountain Lake* (fig. 35) portrayed the approach by water to the hotel. *Prospect House, Dining Room* (fig. 36) and *Prospect House, Piazza* (fig. 37) give a sense of the grandeur of the life and comfort afforded a certain group of tourists who wanted the experience of the Adirondack wilderness, but without unpleasant inconvenience.

Another subject Stoddard wrote about and photographed that added to the perception and lore of the Adirondack wilderness was the Adirondack guide. Richard Roth's dissertation on the subject explores what in some ways became an icon, visually and metaphorically, of the spirit of the Adirondacks in the middle to late nineteenth century (Roth 1990). William Chapman White characterized the Adirondack guide as:

> a limitless fount of stories and yarns, a tracker with the skill of a
> bloodhound, a better shot than Annie Oakley, a chef who could

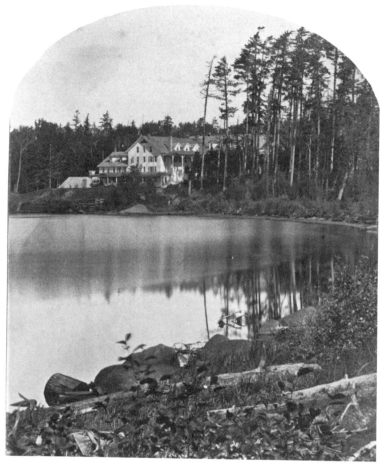

34. *Paul Smith's St. Regis Lake,* 1873. Photograph, 5 x 8½ inches, SRS no. 300. Courtesy of The Adirondack Museum.

take baking powder, flour, and salt and outcook Delmonico's, and an all-knowing rustic philosopher in unchanging costume, his trousers hung from loose suspenders, a felt hat with trout flies in the hatband on his head, and a watch chain dangling into a side pocket. His proudest boast was that he could take a city man into the woods, shoot his deer for him, drag it out, cut it up, and knock down anyone who said the patron hadn't shot it. (White 1985, 153)

Stoddard devoted part of the first chapter of *The Adirondacks:*

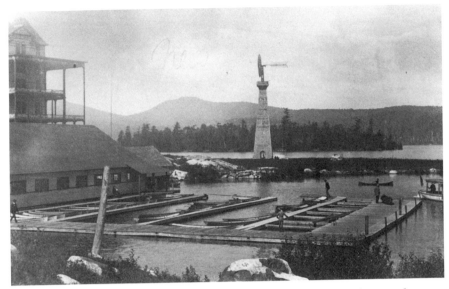

35. *Prospect House Landing, Blue Mountain Lake,* c. 1880s. Photograph, 4¼ x 7¼ inches, SRS no. 693. Courtesy of The Adirondack Museum.

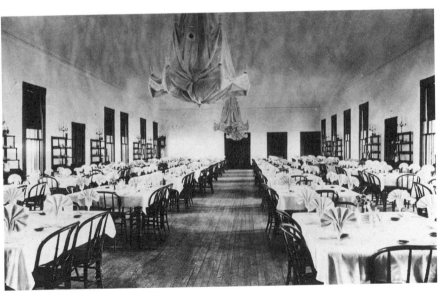

36. *Prospect House, Dining Room,* c. 1880s. Photograph, 4¼ x 7¼ inches, SRS no. 701. Courtesy of The Adirondack Museum.

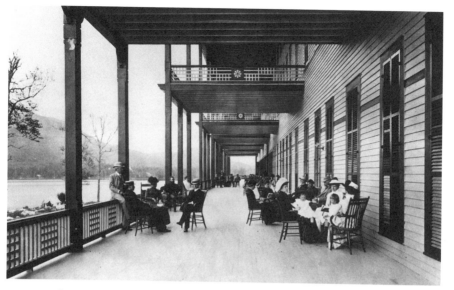

37. _Prospect House, Piazza_, c. 1880s. Photograph, 4¼ x 7¼ inches, SRS no. 702. Courtesy of The Adirondack Museum.

Illustrated to describing the types of guides and the work they performed for the visiting hunter or fisherman. He suggested that independent guides are better because they need repeat business from year to year, while guides paid by the hotels are "responsible to another man for his actions." Stoddard described the costs of hiring a guide and what they would furnish (_AI_ 1874, 7–8).

Stoddard photographed a number of guides including Mitchell Sabattis, Bill Nye, and Mart Moody, but the most celebrated figures were Orson Phelps and Alvah Dunning. Phelps, known as "Old Mountain" Phelps was not a great hunter or trapper, but was a mountain climber, hence his name. He was a Vermonter who had settled in Keene Valley. People were attracted to his manipulation of the English language as well as to his guiding abilities up his favorite mountain, Mount Marcy. Phelps is said to have given his opinion of soap: "Soap is a thing that I hain't no kinder use for" (White 1985, 155). Stoddard's portrait of Phelps (fig. 38) captures his flowing beard and the spirit of this colorful figure. Apparently,

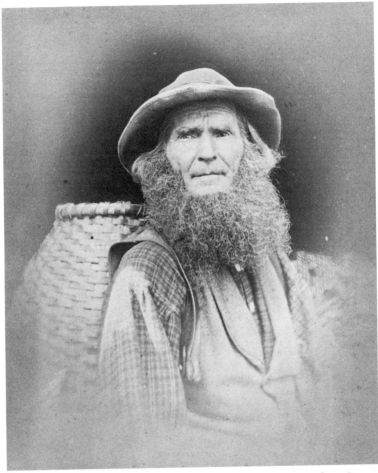

38. *Old Mountain Phelps*, c. 1880s. Photograph, 4¼ x 7¼ inches. Courtesy of The Adirondack Museum.

Phelps sold the images of himself to tourists. Alvah Dunning also took on legendary qualities. He was a quarrelsome individual accused of disregarding game laws. Nevertheless, Dunning was much sought after as a guide, his ornery nature considered part of his charm. The portrait of Dunning made by Stoddard (fig. 39) expresses this proud and independent character. It is clear that Stoddard had high regard for these individuals personally and that they

added an interesting dimension to the lore of wilderness life in the Adirondacks. The more the stories were embellished, supplemented by the images and the marketing of them, the more interest was generated for tourism for the Adirondacks, and the greater the sales.

In addition to these photographs were those commissioned by individuals, which depicted not only the scenic beauty of the Adirondacks but specifically the "great camps" they built and the properties they developed. Beginning in 1879, the same year his cousin Frederick began construction of the Prospect House, William West Durant started work on Camp Pine Knot on Long Point of Raquette Lake. Stoddard wrote:

> The camps of Raquette Lake are elegant affairs, and although built
> of rustic material found ready to the hand, it is apparent that

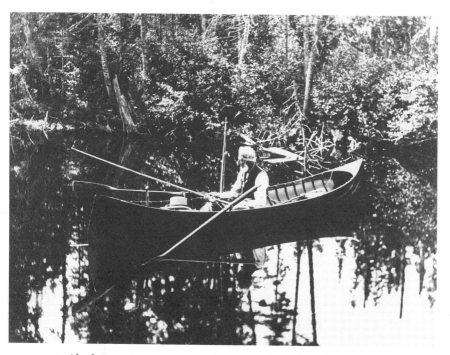

39. *Alvah Dunning,* c. 1880s. Photograph, 4¼ x 7¼ inches. Courtesy of The Adirondack Museum.

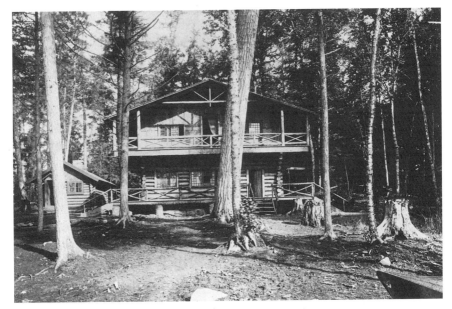

40. *Camp Pine Knot*, n.d. Photograph, 4¼ x 7¼ inches, SRS no. 755. Courtesy of The Adirondack Museum.

twisted cedar, shaggy spruce and silvery birch, in their native vest-
ments, were not chosen because they cost nothing there. Some of
these camps are works of art, and filled with dainty bric-a-brac;
generally however, pertaining to woodsy things, and in keeping
with their native environment. The pioneer camp of this section
and of the most artistic in the woods, is "Camp Pine Knot" on the
South Bay. (*AI* 1889, 106)

Durant's worsening financial situation eventually forced him to
sell Camp Pine Knot, but Stoddard photographed it before the sale.
He made various interior views, including the parlors and dining
room, and of one of the several Pine Knot's cottages (fig. 40). Years
later Durant built Sagamore Lodge on Shedd Lake, which he re-
named Sagamore Lake. Having begun Sagamore in 1896 and added
to it until 1901, Durant sold it because of strained finances. But
during 1899, he produced a privately commissioned album of pho-
tographs with a title page that reads, *Sagamore Park in the Adiron-
dacks Summer Home of William West Durant from Photographs*

by S. R. Stoddard. The album is leatherbound with a cover titled *Sagamore 1899*. It contains thirty-nine of Stoddard's photographs, bound together, with brief captions. The two pages following the title page display hand-colored black-and-white photographs. According to records at the Adirondack Museum, Durant ordered forty-one 11 x 14 and eleven 16 x 20 albums. Stoddard made the photographs in July 1899. In a letter written the following month, Durant mentions an earlier album that Stoddard made of Camp Pine Knot.[3] These special albums were created for presentation to friends, relatives, and business associates.

Stoddard photographed other Great Camps that followed in the Durant architectural tradition, including Camp Fairview, built in 1880 on Osprey Island, at Raquette Lake, by Durant's cousin, C. W. Durant, Jr., and the Cedars on Forked Lake, built by Frederick Durant. The architectural style and decoration of these camps further reinforced what was becoming an Adirondack style, which reflected the romantic view of the region created decades earlier (Kaiser 1982, 95).

Stoddard had originally sold his photographs primarily as separate prints or stereoscopic views, but by the late 1870s and for the remainder of his career, he produced collections relating to specific locations. He promoted them as souvenirs, and they seem certain to have shaped the expectations of the growing numbers of travelers or arm-chair travelers to the region.

The Adirondacks was published in 1878. An advertisement appeared in the 1879 edition of *The Adirondacks: Illustrated*, which described it as a souvenir album containing thirty-two views reproduced by Louis Glaser of Leipzig from original photographs by Stoddard. These images were photomechanically reproduced. The clothbound volume measured 2¾ by 4½ inches. The size was perfect for a souvenir, for it could easily be carried in a pocket or in one's luggage for the trip home. Another of similar size was *Lake George: Photographs* which contained a dozen pages of text

3. The letter is in the manuscript collection of the Adirondack Museum, Blue Mountain Lake.

interleaved with twelve albumen photographs. A publication with the shorter title of *Lake George* appeared earlier, published by Stoddard but containing "artotype illustrations" by Edward Bierstadt. It is not clear whether some of the photographs are by Bierstadt or whether Stoddard was giving him credit for the use of his patented collotype printing process. Nonetheless, it is interesting to have evidence of Stoddard's connection with another important landscape photographer of the time.

Stoddard produced a number of larger coffee-table size books of photographs for the tourist market. He published his *Picturesque American Resorts* in 1892. The title page describes the book as follows:

> Picturesque American Resorts. Phototype views of Lake George, the Adirondacks and the Hudson River Valley. By S. R. Stoddard publisher of guide books and maps of the Adirondacks, Lake George, and Lake Champlain. Art books in photo-gravure, phototype, and half-tone, landscape and genre photographs. Glens Falls, N. Y., 1892.

It contains forty-one pages of plates and a montage of Stoddard photographs opposite the title page. It is interesting to note that two of the photographs are by William Henry Jackson (1843–1942), the official photographer of the Hayden United States Geological Survey from 1870 until 1879. Stoddard most likely made the acquaintance of Jackson through the common experience of being photographers on geologic surveys virtually at the same time, although in different parts of the country.

Stoddard's *Bits of Adirondack Life* was organized with twenty-five pages of single photographs of panoramas and a photographic montage of three guides on the inside cover. He combined a number of themes, the scenic wilderness, and the guides to provide more local interest.

Stoddard was one of the first American photographers to experiment with night photography. He is best-known for *Liberty Enlightening the World,* made in 1890 of the Statue of Liberty in New York harbor. However, he made a number of night photographs in

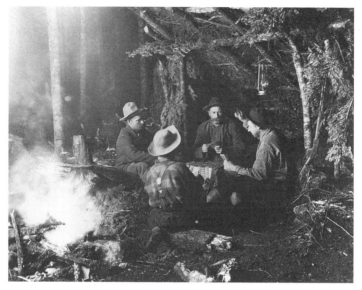

41. *Game in the Adirondacks*, c. 1889. Photograph, 4¼ x 7¼ inches, SRS no. 452. Courtesy of The Adirondack Museum.

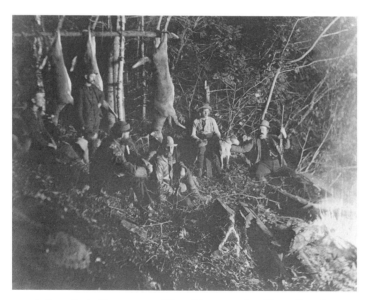

42. *Adirondack Hunters*, c. 1880s. Photograph, 4¼ x 7¼ inches, SRS no. 451. Courtesy of The Adirondack Museum.

the Adirondacks that added another dimension to the corpus of work defining the region as a tourist destination. The "campfire" photographs depicted tourists gathered in the evenings listening to stories and lore of the Adirondacks by the light of a blazing fire. Photographs such as *Game in the Adirondacks* (fig. 41) and *Adirondack Hunters* (fig. 42) typify the image of hunters and guides enjoying the evening hours in the wilderness. It is interesting to note that Stoddard employed a complicated process using magnesium (described earlier) to provide the light for the images, but added the flames of the firelight as part of the developing process. Consequently, the flames have a unnatural quality about them.

Stoddard also employed a technique that simulated night photographs and was referred to as "lunar effect" ("Lunar Effects" 1875). The effect is created by a short exposure to the sun and by making the image when the sun is nearest to the horizon. The combination of these conditions creates shadows that resemble the effect of moonlight. Two examples, *Owl's Head, Long Lake* (fig. 43) and *Blue Mountain Lake, Adirondacks* (fig. 44) demon-

43. *Owl's Head, Long Lake*, c. 1880s. Photograph, 4¼ x 7¼ inches, SRS no. 1073. Courtesy of The Adirondack Museum.

As a Photographer

44. *Blue Mountain Lake, Adirondacks,* c. 1880s. Photograph, 4¼ x 7¼ inches, SRS no. 707. Courtesy of The Adirondack Museum.

strate the long shadows cast by the sun giving the illusion of moonlight on the water. Because of his use of this technique, some of Stoddard's photographs have been characterized as having some of the attributes of luminism.

The concept and characteristics of luminism can be found in some examples of Stoddard's photography. These characteristics not only contribute to comparisons with other nineteenth-century artists in America, but also further Stoddard's perception of the wilderness beauty of the Adirondack landscape. Painters such as John Kensett, Sanford Gifford, and Martin Heade were all associated with the tenets of luminism, and each had painted Lake George before Stoddard had photographed it (Fuller 1987b, 2).

John Fuller notes several Stoddard images that convey the "glassy stillness" found in luminist paintings. *Caldwell, from Fort George Hotel, Lake George* (fig. 45) depicts a mirror image combining the sky and water, with little intrusion by the architecture. The photograph *Lake George, Hulett's Landing* (fig. 46), with its long exposure, presents the water in the foreground with a sheen

45. *Caldwell, from Fort George Hotel, Lake George,* c. 1880s. Photograph, 7¼ x 4¼ inches, SRS no. 1288. Courtesy of The Adirondack Museum.

of light-to-dark tones meeting a rocky shoreline. The water is contrasted with the Dutch-style summer house, which appears out of context, but the stillness of the scene creates a sense of permanence (Fuller 1987b, 2).

Weston Naef suggests the parallel between Stoddard's style in the 1880s and luminist painting when he quotes John Wilmerding's

46. *Lake George, Hulett's Landing,* c. 1880s. Photograph, 4¼ x 7¼ inches, SRS no. 328. Courtesy of The Adirondack Museum.

description of Stoddard's work as having "horizontal order, balanced tonal contrasts, open surfaces of silvery water, and low sunlight faced centrally across the view, its reflection a vertical bar perfectly intersecting the shoreline's horizontals" (Naef 1989, 143). Stoddard's *Little Tupper Lake, Adirondacks,* copyrighted in 1888 (fig. 47), exemplifies all of these characteristics. Again, this image is of a sunset, but owing to the position on the horizon, it emulates moonlight. Wilmerding suggests other Stoddard images that reflect luminist qualities. The view of the Horicon Sketching Club of 1882 (fig. 48), depicting a group of ladies enjoying their leisurely recreation with an orderly balance and stillness of mood, is similar to the paintings and drawings of David Johnson of the same period. Another image, entitled *The Giant, Keene Valley, Adirondacks* of 1888 (fig. 49) is reminiscent of the work of Kensett and William Hart, with the sloping meadows, expansive views of the mountains in the distance, and contrasting tones and shadows of the field (Wilmerding 1989, 142–43). The luminist qualities found in Stoddard's work reinforce the romantic perception of the region.

47. *Little Tupper Lake, Adirondacks*, 1888. Photograph, 4¼ x 7¼ inches, SRS no. 405. Courtesy of The Adirondack Museum.

48. *Horicon Sketching Club*, 1882. Photograph, 4¼ x 7¼ inches, SRS no. 336. Courtesy of The Adirondack Museum.

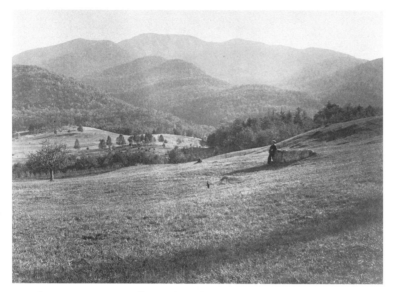

49. *The Giant, Keene Valley, Adirondacks,* 1888. Photograph, 6 x 8½ inches, SRS no.48. Courtesy of The Adirondack Museum.

In contrast to the previously described photographs, Stoddard made a number of images that reflected changes in the Adirondack wilderness landscape and consequently affected how the region was perceived. Stoddard was most certainly influenced by Verplanck Colvin, who oversaw the survey work of the Adirondacks in the 1870s and 1880s. Stoddard accompanied the survey teams and documented the landscape photographically as Colvin measured it topographically, beginning in 1872 with the establishment of the State Park Commission. Colvin and his survey party climbed Mount Marcy and provided measurements for it and also found the small pond, Tear-of-the-Clouds, that was determined to be the source of the Hudson River. Stoddard's subsequent image of the inland lake has been widely reproduced (fig. 50). Colvin's assessment of change in the Adirondacks is important to note. In 1880, Colvin wrote:

> Viewed from the standpoint of my own exploration, the rapidity
> with which certain changes take place in the opening up to travel

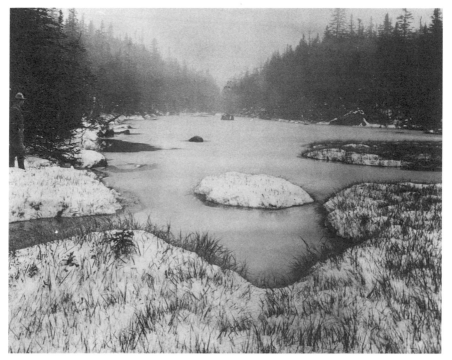

50. *Lake "Tear-of-the-Clouds,"* c. 1880s. Photograph, 6 x 8 inches, SRS no. 433. Courtesy of The Adirondack Museum.

of the wild corners of the wilderness has about it something most startling. The first romance is gone forever. It is almost as wild and quite as beautiful: but, close behind our exploring footsteps came the blazed line marked with axe upon the trees, the trail soon trodden, the bark shanty, picturesque enough but soon enough surrounded by a grove of stumps. I find following then the ubiquitous tourist, determined to see all that has been recorded as worth seeing. Where first comes one, the next year there are ten, the year after, fully a hundred. Hotels spring up as though by magic and the air resounds with laughter, fun, and jollity. The wild trails, once jammed with logs, are cut clear by the axes of the guides and ladies clamber to the summits of those once untrodden peaks. The genius of change has possession of the land. We cannot control it. When we study the necessities of our people, we would not control it if we could. (Colvin 1880, 27)

Colvin clearly understood the changes but seems to have valued progress and civilization over an appreciation and concern for the wilderness aesthetic (Terrie 1985, 90). Nonetheless, beginning in this period, Stoddard's photographs reflect the changing landscape and the changing attitudes about it. The image *Drowned Lands of the Lower Raquette, Adirondacks,* copyrighted in 1888 (fig. 51), portrays the desolation from dams created to improve navigation for steamboats or for mill purposes and the subsequent flooding. The isolated figure sitting on one of the uprooted trees is surrounded by the haunting landscape. The image was most likely made before the painting of the same subject described earlier. This single image stands in vivid juxtaposition to the hundreds of scenic views of the region Stoddard produced.

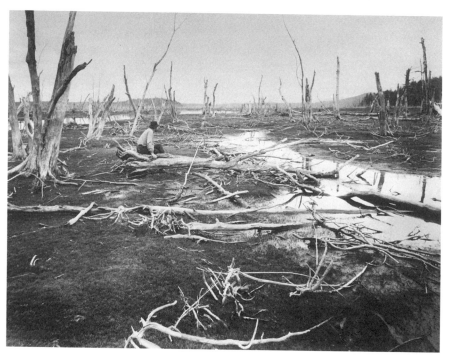

51. *Drowned Lands of the Lower Raquette, Adirondacks,* c. 1888. Photograph, 4¼ x 7¼ inches, SRS no. 433. Courtesy of The Adirondack Museum.

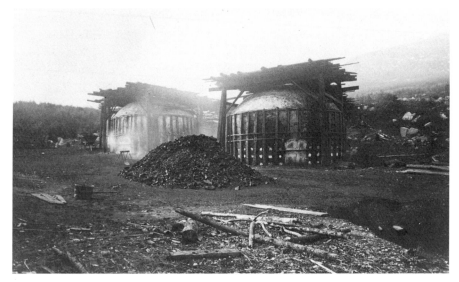

52. *Charcoal Kilns, Adirondacks,* 1891. Photograph, 4¼ x 7¼ inches, SRS no. 495. Courtesy of The Adirondack Museum.

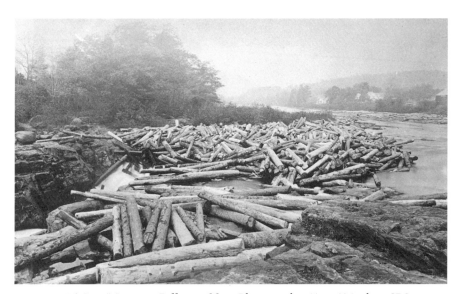

53. *"A Jam," Luzerne Falls,* c. 1880s. Photograph, 4¼ x 7¼ inches, SRS no. 636. Courtesy of The Adirondack Museum.

Other images of the region described the changing, and not nec-
essarily positive, view of the wilderness landscape. While pho-
tographs of hotels, transportation, and associated activities
provided one view, those of logging and the development of vari-
ous industries signaled another. Stoddard's *Charcoal Kilns,
Adirondacks,* copyrighted in 1891 (fig. 52), shows a group of peo-
ple awaiting a steamboat in the foreground, while the horizontal
plane of the photograph is dominated by a strip of charcoal kilns
along the shore of the lake. The land immediately behind the kilns
has been leveled, and smoke emanates, it appears, from both the
steamboat and the charcoal production. Stoddard also made nu-
merous images of the logging industry. Some have a romantic tone
to them, glorifying the outdoors and woodmen, but many show
the denuded landscape that contributed to flooding and fires. An
image such as *"A Jam," Luzerne Falls* (fig. 53), shows the magni-
tude of the logging and its attendant danger not only to those
working in the logging industry, but to the physical environment.
John Fuller points out the contrasts between nature and industry
in Stoddard's *Wheel House of Ausable Chasm, Horse Nail Works,*
which is not dated (fig. 54); it portrays the foreshortened falls with
an extremely tall wheel tower in the distance. The white foam of
the falls is contrasted with the clarity and centrality of the tower.
Fuller suggests that this "hints of a gothic tale rather than a factual
statement about the nail industry" (Fuller 1987a, 222). One sup-
poses that Stoddard mixed these ideas to create a certain composi-
tion, knowing full well what contrasts were represented.

Stoddard's presentation before the New York State Legislature
in February 1892 in support of creating an Adirondack park com-
bined images of the beauty of the Adirondack region with the
abuses he had documented. The majority of the presentation was
represented by his scenic views of the Adirondacks, but Stoddard,
according to the newspaper accounts, talked at some length about
the policy of creating dams that resulted in the "drowned lands"
he documented. He concluded the lecture with his poem related to
the course of the Hudson River. Again, his photographs were

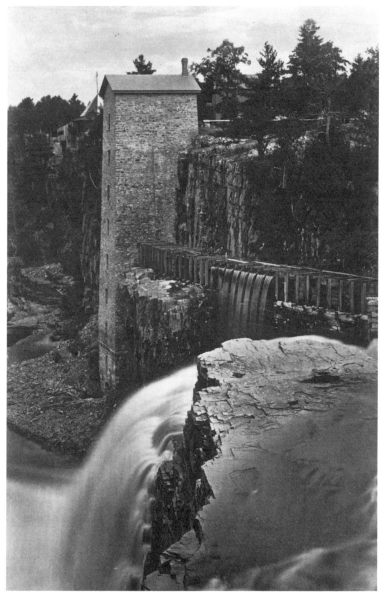

54. *Wheel House of Ausable Chasm, Horse Nail Works,* c. 1880s.
Photograph, 4¼ x 7¼ inches, SRS no. 371. Courtesy of The Adirondack
Museum.

shown simultaneously. Stoddard also included photographs of state officers and legislators, which seemed politically astute. This presentation was a factor in the passage of the legislation several months later.

Stoddard exerted a great deal of influence on the perception of the Adirondack wilderness from the 1870s through the first several decades of the twentieth century. His textual contributions in the form of guidebooks began and continued in the early part of his career, following and developing the romantic tradition of the wilderness. However, later in his career, Stoddard wrote in support of protection of the Adirondack wilderness. Stoddard's photographic imagery followed a similar pattern. Even though he continued to use the scenic, romantic views in a variety of publications, he used images such as the "drowned lands" to illustrate his concern about the changing landscape.

4 Stoddard, Wilderness, and Tourism in the Adirondacks

Seneca Ray Stoddard influenced the perception of the Adirondack wilderness for individuals who traveled to the Adirondacks as well as for those who never visited the region. The tourist industry in the United States in general, and in the Adirondacks in particular, was just beginning to emerge in the nineteenth century. Contemporary research on tourism suggests that the concept should be understood and studied from a variety of disciplines. W. Hunziker, in Douglas Pearce and Richard Butler's work, provides what is now regarded as a classic definition: "Tourism is the sum of the relations and phenomena which result from traveling and visiting an area by non-residents providing that it does not entail resettlement or paid work" (Pearce and Butler 1993, 9).

Krzysztof Przeclawski, in his essay "Tourism as the Subject of Interdisciplinary Research," gives the following definition: "Tourism, in its broad sense, is the sum of the phenomena pertaining to spacial mobility, connected with a voluntary, temporary change of place, the rhythm of life and its environment and involving personal contact with the visited environment (natural, cultural or social)" (Pearce and Butler 1993, 10). He goes on to say that thinking of tourism simply as a form of leisure is too limiting. Tourism should be thought of as our attitude toward space and treated as part of our process of spatial mobility. Tourism also has economic, psychological, social, and cultural attributes. As an economic phenomenon, tourism often develops with the creation of supply and demand. The psychological association with tourism

denotes specific needs for traveling; preconceived images of what the trip will be like are often compared with the reality while traveling. There is also a social dimension to tourism in that social contacts are made with fellow travelers, trip organizers, guides, and individuals from the local population. Social images of a destination may motivate certain travelers, and social ties may develop. Tourism can simultaneously be a function and manifestation of culture and can have a transforming influence on a particular cultural environment (12).

Pleasure travel offers relaxation from everyday routines and a temporary escape from common and familiar surroundings. Max Kaplan describes how individuals react to the experience of travel. Some are characterized as "comparative strangers" who physically travel but seldom have their viewpoint or perspective changed by what they experience. These individuals usually have a preconceived idea of what they will see and gain a sense of security in holding on to these ideas. In contrast, Kaplan describes the "emphatic natives" who put themselves in the place of those they visit. These individuals seek and use new viewpoints to change how they think and view the world. Kaplan suggests that most travelers are somewhere between these two extremes (Kaplan 1960, 215).

The sociologist Eric Cohen describes various ways in which tourists explore the world around them. Many have a recreational expectation of traveling—they search for some sort of entertainment as if it were a theatrical production. These individuals almost accept a make-believe world. Other experience travel as a diversion; they seek escape, often merely a change of location (Cohen 1979, 192).

The concept of tourists and tourism often carries negative connotations. The geographer Edward Ralph views tourism as "an inauthentic attitude towards place." He believes that tourism becomes more important than places and that people are unable to be objective about the places they visit (Ralph 1976, 83).

In understanding the history of travel, Eric Leed notes that the

meaning of travel has changed quite dramatically over genera-
tions. For the ancients, travel was a necessity, fated, and some-
thing to be endured. The epic travels narrated in the *Odyssey*, for
example, were decreed by the gods and therefore neither voluntary
nor enjoyable. In the postmedieval world, travel became a voyage
of discovery, which lead to scientific expeditions. The Romantics
saw freedom as an important aspect of travel; the ability to travel
corresponded to autonomy, and travel became an intellectual plea-
sure (Leed 1991, 7–13).

Leed goes on to suggest that the voluntariness of departure,
travel free from necessity, and travel signifying autonomy remain
the characteristics of travel in the modern world. Travel "for no
reason at all" provides access to the objective world and new in-
formation rather than a means of revealing "ungovernable forces
beyond human control" (Leed 1991, 14).

Travel encourages and develops a cultural self-image, and con-
tributes to cultural change. Leed summarizes the changes in the
documented history of travel as follows:

> The history of travel is the study of a force—mobility—that has
> shaped human history and is observably at work in our present.
> Mobility is a force of change operating through different events that
> make up the structure of the journey: departure, passage, and ar-
> rival. The transformations of travel are an accumulation of effects
> from this sequence of distinctive situations: from departures that
> detach individuals from a familiar context; from passages that set
> them in motion across space; from arrivals that establish new
> bonds and identifications between strangers, creating a new union
> and coherence between self and context. Each of these events has
> its specific character and must be examined in its own right. Needs
> are a product of situations . . . and each of these events, through
> many repetitions, produces and serves a particular set of needs. De-
> parture may serve the need for detachment, purification, liberty,
> "individuality," escape, self-definition. Passage serves and generates
> a need for motion but may, in turn, generate other longings: for sta-
> bility in a condition of disequilibrium, for fixed orientation in a
> world of flux, for immutability in the midst of transience. Arrivals
> serve a need for human association, for membership, definition,

even confinement, and may, in turn, engender a growing desire for departure, liberty, and escape. In any one place and moment, these needs may be perceived as opposed and conflictual, but they are not when sequenced in the form of the journey. Here may lie the eternal appeal of travel—it resolves a logic of contradiction, a logic of place, into a logic of sequence, an order of change and transformation which serves and fosters a variety of human longings: for motion and rest, liberty and confinement, indeterminacy and definition. (Leed 1991, 21–22)

By the last quarter of the eighteenth century, tourism was well established in Europe generally and was especially strong in England. With the increasing popularity of landscape gardening and painting as well as the publication of essays on the sublime and the picturesque, prosperous Englishmen sought travel as an opportunity to search for equivalent scenery (Sears 1989, 3). The nineteenth century was characterized by important changes that ultimately influenced tourism in America. A significant factor was the urbanization of the population. The growth of cities, based upon increasing technology and the development of manufacturing jobs, rapidly expanded the middle class. In the early to middle decades of the nineteenth century, the urban population was not more than a single generation removed from rural, agricultural life. By the end of the century, several generations of city dwellers were common. The urban concentration created a middle class of professionals, bankers, and government employees, and a market for travel developed for a literate and relatively financially secure elite (Burkart and Medlik 1974, 22).

By the middle of the nineteenth century, travel by steamship, on both inland waterways and the ocean, met a need for relatively fast and comfortable travel. After the Civil War, Americans began traveling to Great Britain and the Continent in ever-increasing numbers. The railroad industry, too, created similar opportunities. The railroad made it possible to live at some distance from work and helped create a distinction between work and leisure previously unheard of. Thus evolved the idea of an annual holiday, which became a fairly standard condition of employment. From

this concept developed the need for hotels and resorts to accommodate these annual visitors. The hotels were more than places in which to sleep; they were the base of operation for a variety of tourist activities (Burkart and Medlik 1974, 22–23).

Sears also suggests that tourism requires a body of images and descriptions of places, "a mythology of unusual things to see," which stimulates people's imagination and interest in travel (1989, 3). Such a body did not really exist in America until the 1820s and 1830s. Travel did not merely satisfy a need for diversion; it also contributed much to America's creation of a cultural identity. As described earlier, the eighteenth- and early-nineteenth-century tradition of landscape gardening and the aesthetics of the sublime and picturesque, which translated into painting and subsequently into photography, closely linked culture and landscape. In the early nineteenth century, Americans were searching for a national identity, and the land that they had settled was an obvious choice. There was an important sense of wanting to meet European standards of culture, but also to create a separate identity. The history of her relationship with Europe made it necessary for America to create an identity of her own, and the development of tourism and tourist destinations played a very important part in establishing that identity (Sears 1989, 4). Some would argue that European cultures, particularly in reference to the English landscape, created their own identities, and for this reason Americans were not unusual in attempting to do so.

Americans partially defined their national identity by the manner in which they traveled and how they recorded their journeys. Again, as described earlier, beginning in the 1820s, artists including Thomas Cole, Frederic Church, and Albert Bierstadt depicted tourist attractions in their work. Writers such as Washington Irving, Nathaniel Hawthorne, and Henry James defined Americans in their descriptions of travel in Europe and in the portrayals of American tourist attractions that they incorporated into their fiction. These artists and writers contributed to the creation of images of America, either because they depicted already well-known

places or because the fame of their work made these places, in turn, famous. Thus, they created a value and identity for the places they described and helped shape the images of those who visited or would potentially visit them. Serious and popular artists and writers created images and descriptions through guidebooks, novels, magazines, picture books, and stereographs, all of which enhanced the identity of America and fostered travel and tourism (Sears 1989, 5).

Early in the nineteenth century, American tourists often referred to themselves as "pilgrims." Although Protestants in America had rejected the concept of pilgrimages, the use of the term suggests, nevertheless, that tourist attractions adopted the association of sacred places. Tourism and pilgrimages provide escape from ordinary life and a sense of spiritual renewal through some sort of transcendent reality. Often there was the hope, as well, of physical renewal or "cure" from medicinal waters. A tourist was often "half a pilgrim, if a pilgrim is half a tourist" (Turner and Turner 1978, 20).

The interest in travel in the nineteenth century was evident in members of both sexes in American society. Annette Kolodny suggests, however, that male and female perceptions about the American frontier were quite different. According to Kolodny, men saw the wilderness as fertile land to be conquered and dreamed of transforming it and producing wealth from it. By contrast, women thought in terms of homes, communities, and gardens (1984, 3–12). Aside from the inclusion of hunting and fishing as part of tourism, the sexes did not differ significantly in their perceptions of travel. As the nineteenth century progressed, there was less of an emphasis on the utilitarian value of the American landscape and more on its value for cultural purposes, and tourism was an important influence on this change in thinking.

Two other nineteenth-century changes that affected tourism were the growth of a secular, upper middle class and the development of consumerism. One can argue that consumerism in America did not fully develop until the latter part of the nineteenth

century, but elements appeared before the Civil War with the establishment of department stores, national expositions, and tourism itself. Tourist attractions were indeed consumer products. The transportation systems, including steamboats and then railroads, and the hotel industry played integral roles in realizing the needs of the ever-increasing numbers of tourists. Initially, tourists were motivated by cultural and even religious concerns, but by the last quarter of the nineteenth century, tourism was a mass phenomenon and considerably more commercial (Sears 1989, 9–10).

The patterns of tourism in the Adirondacks in the nineteenth century closely resembled national patterns. The early visitors to the Adirondacks at the turn of the nineteenth century were primarily concerned with the natural resources the land could provide, especially lumber. But following Emmon's survey of 1837, which included the artist Charles Ingham, the world began to see images of the Adirondacks that sparked potential interest in tourism. The general public was surprised by the magnitude of the Adirondack wilderness depicted in Emmon's report and Ingham's images (Graham 1978, 12–13).

This increased awareness and appreciation of the Adirondacks as a tourist destination was fueled by books such as Joel Headley's *The Adirondack; or Life in the Woods,* published in 1849, which described the pleasures a tourist would find in the Adirondacks. Headley praised the wilderness and promoted travel to the region by saying that anyone could enjoy an Adirondack vacation and "come back to civilized life a healthier and better man" (45–46). Headley's book became a prime example of the illustrated romantic travel literature that would become a standard over succeeding decades. He included all the appropriate and expected information: how to reach the woods and prepare for a camping trip and descriptions of hunting and fishing, of life in the woods with guides, and of scenery (Terrie 1985, 44).

To many Adirondack tourists, an expression of appreciation of the wilderness was a response to "scenes," to an arrangement of certain natural elements found in paintings of the time. William

Gilpin wrote, *"Picturesque beauty* is a phrase but little under-
stood. We precisely mean by it that kind of beauty which *would
look well in a picture"* (1798, 328). For example Thomas Cole said
in a description of the landscape in the Schroon Lake area, "I do
not remember to have seen in Italy a composition so beautiful or
pictorial as this glorious range of the Adirondack." Cole, despite
the glowing description, was judging the landscape on its compo-
sition and how it would fit on a canvas (Noble 1964, 177). As de-
scribed earlier, a succession of writers and artists traveled to the
region to document their impressions, which reached a mass au-
dience, particularly after the Civil War. The 1850s brought
William Stillman and his Cambridge colleagues to the Adiron-
dacks, and the founding of what was to be called "the Philoso-
phers' Camp." They sought a refuge to contemplate the natural
wilderness and the spiritual ideals associated with such a setting.
But the publication of William H. H. Murray's *Adventures in the
Wilderness* in April 1869 was indeed a very important factor in de-
veloping the tourist industry of the Adirondacks. The correspon-
dent to the *Boston Daily Advertiser,* "Wachusett,"[1] wrote about
the book:

> Mr. Murray's pen has brought a host of visitors into the Wilder-
> ness, such as it has never seen before—consumptives craving pure
> air, dyspeptics wandering after appetites, sportsmen hitherto con-
> tent with small games and few fish, veteran tourists in search of
> novelty, weary workers hungering for perfect rest, ladies who have
> thought climbing the White Mountains the utmost possible
> achievement of feminine strength, journalists and lecturers of both
> sexes looking for material for the dainty palate of the public, come
> in parties of twos and dozens, and make up in the aggregate a mul-
> titude which crowds the hotels and clamors for guides, and threat-
> ens to turn the Wilderness into a Saratoga of fashionable
> costliness. (Wachusett 1869)

Years later, Murray wrote of the public reaction to the book:

1. On the basis of entries in hotel registers, William K. Verner has tentatively
identified Wachusett as George B. Wood (see Cadbury's "Introduction" to Murray's
Adventures in the Wilderness, 40).

The great, ignorant, stay-at-home, egotistic world laughed and jeered and tried to roar the book down. They called it a fraud and a hoax. The pictorials of the day blazoned their broadsides with caricatures of "Murray and his fools." Innumerable articles were written to the press, and editorials published, denying that there were any such extent of woods in the State, any such number of lakes, any such phenomenal connection of waterways, any such possibilities of pleasure and health as the little book portrayed. But the facts of geography and the truth of nature were in it, and it successfully breasted the adverse criticism and hostile comment of innuendo and jeer, and carried the fame of the (Adirondack) woods over the continent. (Murray 1890, 118)

By either its content or its controversy, Murray's book became a best-seller and reached an audience of thousands of would-be travelers. Within weeks of the book's publication, hundreds of individuals left the cities for the Adirondacks. Some railroads offered a free copy of the book with the purchase of a round-trip ticket. The initial impression of many of the tourists was not a positive one. The flood of visitors met overextended hotels and guides, and many felt exploited by the local entrepreneurs. As a result, many did not venture further than the perimeter of the Adirondacks and were disappointed by the lack of adventure and wilderness they had anticipated. In addition, that first summer after the publication of the book was particularly rainy, and consequently deer did not come down from the mountains to their usual watering places, and the black fly season was unusually long and intense (Graham 1978, 28–29). Despite the outcry over Murray's book, it provided a summary of a lifestyle in the wilderness that captivated a large segment of the potential traveling public.

Up until 1871, with the opening of Durant's Adirondack Railroad from Saratoga Springs to North Creek, there were few lodgings in the central Adirondacks. In 1874, John Holland built the Blue Mountain Lake Hotel, the first large hotel in the region. This project was greeted with enthusiasm from entrepreneurs such as Durant, for it provided a convenient destination (via stagecoach) to his railroad in North Creek. Holland's initial hotel accommodated

forty guests. It burned in 1886 and was rebuilt and opened in the following year, greatly expanded to house between three and four hundred visitors. The costs of construction and operations of this and other large hotels were excessive, considering the short summer tourist season (Hochschild 1962b, 1–3). Holland's hotel was again destroyed by fire in 1903; it was rebuilt and remains today as Potter's Cabins and Restaurant on the north shore of Blue Mountain Lake. Several other hotels were established in the mid-1870s, including the Blue Mountain House and the Ordway House, which increased competition for stagecoach lines delivering tourists to the hotels.

In the summer of 1882, Frederick Durant, son of Charles Durant and nephew of the railroad builder Thomas Durant, opened the Prospect House on Blue Mountain Lake, which accommodated five hundred guests. Although its exterior was not exceptional from an architectural perspective, its interior was one of the most luxurious of the day. It included electric lights, a steam elevator, and a bowling alley. The elaborate system of steam heat in the guest rooms was often described as a unique feature of the hotel.

Some have suggested that between 1882 and 1890, Blue Mountain Lake and its immediate environment was the most fashionable resort area in the northern part of the United States (Hochschild 1962b, 43). The inaccessibility of the area was appealing to those who had the means and leisure to make the trip. From New York City, the journey took approximately twenty-six hours via steamboat to Albany, the railroad to North Creek, and the stagecoach to Blue Mountain Lake. The time and the physical discomfort, particularly the stagecoach ride, were the price for enjoying the beauties of the wilderness landscape. Writers in urban areas promoted the Adirondacks and the Blue Mountain Lake region as superior to the European spas. Blue Mountain Lake became the starting point for canoe and guide-boat trips through the Adirondacks. In addition, rowing and swimming races, tennis tournaments, bowling contests, and rifle matches were frequent activities of hotel guests. The following is but one account, from

the *New York Telegram* of August 16, 1882, that gives the flavor of the hotel life of the period:

> The guests of the Prospect House, at Blue Mountain Lake, gave a brilliant *fete* on the water a few evenings since. It was one of the prettiest and most novel sights ever witnessed in the wilderness, where the only illuminations heretofore have been the "Jack lights" of the hunter.
>
> The little steamer Toowahloondad having been chartered for the occasion was decorated with bunting, colored lights and lanterns, carried the band under the direction of Professor Henry Giessman, of New York, who is to be complimented upon his well chosen selections. During the interlude of the band the voices of several jubilee singers, who were at the extreme end of the line, added much to the enjoyment of the evening.
>
> The steamer then started upon a tour among the numerous islands, having in tow the rowboats—some seventy-five or more—of the hotel and invited camps. These boats were all beautifully illuminated with lanterns of great variety, many of which were the handiwork of the ladies of the hotel. The night was dark, but Bengal lights placed on tiny floats upon the water and barrels of inflammable materials at various points flooded the scene with many colored lights, which were duplicated by reflection in the placid lake.
>
> One of the features of the evening was the firing of a cannon from a rock at the lower end of the lake, the echoes of which bounded and rebounded among the surrounding mountains. Mr. Duryea's camp located near the Prospect House, also displayed many Japanese lanterns.
>
> The spectacle, whether viewed from the boats or from the shore, was animated and beautiful in the extreme and elicited rapturous expressions of delight from all who saw it. For the success of the carnival thanks are due to Dr. W. B. Hubbard, of New York, who filled the position of grand marshall with much credit, and to his aides Messrs. J. A. Hance, R. K. Hance, and F. C. Durant. To fully appreciate the novelty of this place one should have been here during the past week and witnessed the exciting sport attending the capture and killing of several deer.

This description suggests, particularly in the last sentence, the diversity of activities the hotel guests engaged in during their stay. It

is also interesting to note the names of sponsors of the event described. Individuals such as Durant had an obvious investment, through the railroad and stagecoach lines, in supporting the attractions that would entice tourists to the region and necessitate travel by way of his family's various enterprises. This interconnectedness and interdependency of the tourist industry in the Adirondacks went well beyond the hotel and related transportation businesses. Artists, writers, and photographers such as Stoddard were also part of the network that developed and transformed the region.

There are a variety of ways to understand how Stoddard's work was received. The success and longevity of his guidebook series, and the sheer number of photographs sold and reproduced, are but one way to measure the reception of his work. The reactions in the press, primarily in newspapers and photographic periodicals, are another important gauge of his success. Stoddard's earlier career as a portrait and landscape painter in Glens Falls no doubt gave him some notoriety, but these articles demonstrate that from an early point in Stoddard's career, he was recognized in his community as having talent in portraying the beauty of the local landscape by means of the camera. Again, his stature in the community prompted newspaper articles about his travels, including the first trip he made into the interior of the Adirondacks in 1870 and the subsequent one in 1873, which were described in depth earlier.

Beginning in the mid-1870s, Stoddard's reputation expanded with the publication of his various guidebooks, as did the attention he received in the professional photographic journals of the period. In an article entitled "Lunar Effects" (1875), Stoddard's technique was recognized for creating the impression of a moonlit scene by manipulating a short exposure to the sun. This was to become a popular device, but Stoddard was one of the first to employ it when photographing the Adirondacks. The article makes it clear that Stoddard sent the periodical the image, along with other stereographs, for review and, he hoped, some written notice.

In the following year, Stoddard exhibited a number of his

Adirondack photographs at the Philadelphia Centennial Exposition (Fuller 1987a, 224), where they were seen by thousands of visitors. In the same year, a lengthy commentary appeared in a regular feature of *The Philadelphia Photographer* entitled "Our Picture" and devoted to Stoddard. Stoddard's photograph *Ausable Chasm—Grand Flume from the Rapids Down.* (fig. 55) was the centerpiece of the feature. Stoddard is described as someone equally skillful with the camera and the pen:

> Mr. Stoddard has courted Nature in all her moods; on Lake George and Champlain in the rugged and mysterious Ausable Chasm, and among the wilds of the celebrated Adirondacks, till he has furnished the finest photographic views of those regions that have ever been published. Not content with telling the story in his pictures, he has sought to make that section better known and more accessible to the ever-swelling tide of pleasure seekers which every year sweeps in that direction, by publishing three different books, viz: *Ticonderoga, Lake George Illustrated,* and *The Adirondacks Illustrated.*

The bulk of the succeeding text is a quote from Stoddard's publications devoted to the beauty and curiosity of nature. The concluding paragraphs praise Stoddard's technical ability and go further by saying:

> The excellence of Mr. Stoddard's work will be apparent upon a careful examination. The point he has chosen for giving the best view both of the rugged wall and the swiftly flowing river, the time of day when the sunlight illumines the narrow gorge, and brings every detail into view as far as the eye can reach giving a beautiful play of light and shade throughout the whole, indicate a trained judgment and fidelity to conviction which are sure to command success. By fidelity to conviction we mean that love for truth and art which will not sanction the taking of a view under any but the most favorable circumstances. The photographer, who is true to what he knows to be right, will refuse to expose a plate on a view unless it be from the right position and in the best light; he will wait several hours, will photograph some other spot, or come at the proper hour another day. The man who would think all this is a waste of time, and with little regard, either from lack

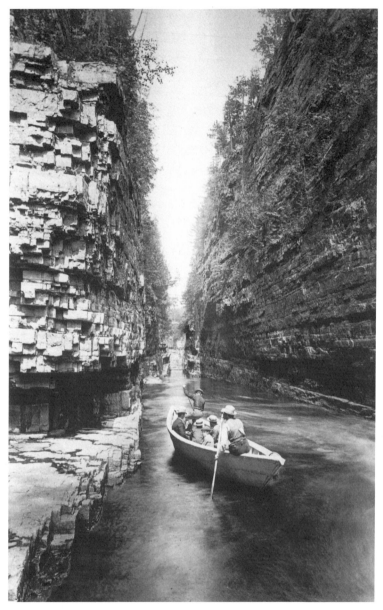

55. *Ausable Chasm—Grand Flume from the Rapids Down,* c. 1870s.
Photograph, 4¼ x 7¼ inches, SRS no. 399. Courtesy of The Adirondack
Museum.

of knowledge or principle, for the truth of the work, or the best conditions, would take a view at whatever time he chanced to come upon it, whether in sunshine or shadow, in a flat light or in full relief. The good work produced by such a one are accidents, and are likely to prove the exception; the other keeps all conditions in subjection as far as possible, and good work with him is a duty, from which no inducements can tempt him to swerve. This is a point which requires to be well considered by all landscape photographers as one of the most important lessons connected with this department of our art. The first is to learn what is right and proper to be done, and the next, from principle as well as policy, to do that right and proper thing.

We trust Mr. Stoddard's excellent work will stimulate many others to strive for a higher standard of landscape photography, and not much longer suffer America to be outdone by the artists of the Old World. There is an immense field open, and, to the lover of the beautiful in nature, a most fascinating and profitable one.

In this article, Stoddard is portrayed as having achieved the ability to create landscape art. There is no evidence to suggest that Stoddard had any real desire to promote photography as a fine art generally and his own specifically. But this type of review of Stoddard's work for a photographically interested readership was modest compared with the publicity he would receive within the next decade.

In 1877, several more articles were published related to Stoddard's work. The editors of *The Philadelphia Photographer* featured Stoddard's *Upper Ausable Lake from Boreas Bay* (fig. 56) as the frontispiece of the May issue and wrote the following:

> Mr. Stoddard, who is not only a thoroughly good photographer, but he is thoroughly imbued with true artistic feeling, as is plainly evident from the examples of work which he sends for our present illustration. Not only this, Mr. Stoddard is quite a famous author, and has written in graphical and humorous style several illustrated works, one upon Lake George, and one upon the Adirondacks, which he publishes and sells to the visitors at these celebrated health resorts, and to the rest of mankind.
>
> Too much credit cannot be given to Mr. Stoddard for the way in which he has worked up photography in the particular section

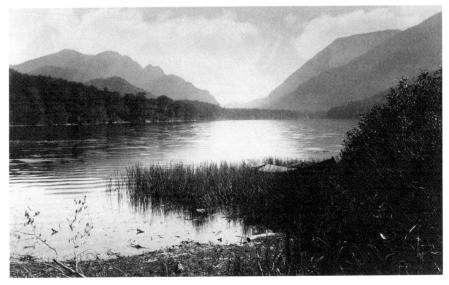

56. *Upper Ausable Lake from Boreas Bay*, c. 1870s. Photograph, 4¼ x 7¼ inches, SRS no. 34. Courtesy of The Adirondack Museum.

which is known as his field of labor. The number of magnificent views he has made is almost numberless, and we believe he is reaping the reward which energy, and perseverance, and hold-on-a-tiveness, and good work, and minding one's own business, always bring.

It appears from this description that Stoddard is noted not only for his photographs, but also for his writing. Stoddard seems to be known for his particular "section," the Adirondacks. His association with the region over time added credibility to what he said, wrote, and photographed about it. In reference to the publication of *The Adirondacks; Illustrated* and *Lake George: Illustrated* in that same year, the following was written: "We never read them without wanting to visit the scenes which they describe, and we suppose it is the author's object to *create* such a want among his readers, and if he succeeds, then he is, indeed, a good artist, as, indeed, our friend Stoddard is" ("Editor's Table" 1877, 256). Stoddard is being judged as successful, in the editor's opinion, because his

writing and photographs "create a want among his readers" to visit the scenes he describes in words and images. This was exactly Stoddard's intent.

A final article from the May 1878 *Philadelphia Photographer* reaffirms Stoddard's reputation as an excellent landscape photographer and as an example for others to emulate:

> We know of no more careful and conscientious landscape photographer than Mr. Stoddard, and therefore none whose work is more worthy of study by his fellow-craft than his is. There are many photographers who are very familiar with all the rules for producing the finest results, but who are most careless in following those rules in their practice. Mr. Stoddard is evidently not that kind, as his work eminently testifies. The man who produces the best work is he who, when going through his varied manipulations, suffers himself to become his own most exacting taskmaster, and who obeys every rule which he knows to be of service in securing the best result. There is nothing so ruinous in any work as to allow one's self to grow into the slip-shod, careless, and sloven habit of ignoring the best rules for securing the best results, and in no branch of art or industry is this more true than in photography, and in no branch of photography is it more true than in the department of landscape photography.

In the decade of the 1880s, Stoddard's reputation reached a much larger audience with the inclusion of his photographs and excerpts of his writing in popular news magazines. This exposure in the popular press was instrumental in securing for Stoddard the title of "Adirondack photographer," and it provided images and descriptions of the region, not only for traveling Americans, but for those abroad as well. Articles illustrated with Stoddard's work in *Frank Leslie's Illustrated Newspaper* in 1887 and in *Harper's Weekly* the following year reached thousands of readers. The article "Adirondack Woods, Waters and Camps" that appeared in *Frank Leslie's Illustrated Newspaper* on August 13, 1887, described the scenery of Blue Mountain and Raquette Lakes and explained how the traveler would reach the area. The text was accompanied by seven engravings of Stoddard photographs. Stod-

dard's technique for photographing at night brought him much publicity, which translated into further recognition of his work, regionally and nationally. During the 1880s he made a number of night images using magnesium flash powder to illuminate the subject. As described previously, most of these images were of evening outdoor activities around the campfires at the various hotels in the Adirondacks. These images enhanced the attraction of the region for those wishing to visit and participate in the Adirondack experience, which was promoted by the hotel proprietors. Stoddard's greatest recognition with regard to his night scenes came with his photographs of the Washington Square Arch in New York City and the Statue of Liberty. The notoriety came partly from the technique and its results, but also from the danger associated with it. The production of these images was widely reported in the press, and Stoddard, "the Adirondack photographer," was credited with the latest advancement of the technique.[2]

The reception of Stoddard as a lecturer on the Adirondacks, and in particular his presentation before the New York State Legislature in 1892 regarding the "forever wild" legislation, paralleled a critical transformation of the perception of the wilderness landscape of the region. As noted earlier, Stoddard's presentation of approximately 225 of his Adirondack images and of his poetry, as well as his ability to engage an audience with fact and humor, made a remarkable impression. Stoddard cleverly included images of some of the political figures in attendance that evening. The response to the presentation was extremely positive and was reported in newspapers throughout the state. He was able to describe the beauty and pleasures of the Adirondack wilderness and also make the case for the dangers associated with not protecting it. An article from the *Albany Evening Journal* entitled "A Tour on Canvas, Beauties of the Adirondacks Shown in the Assembly Cham-

2. An account of Stoddard photographing the Washington Square Arch is found in "Flash Light Photography Out-of-Doors," in *The Photographic Times and American Photographer*, Nov. 8, 1889, 559–60; that of the Statue of Liberty is documented in "Taking Pictures at Night" New York Tribune, March 2, 1890, 17.

ber" that ran on February 26, the day after the presentation, began by saying, "Professor Stoddard leads his hearers up mountains and along pretty rivers—The Chamber filled with 'tourists,' and all delighted with the lecture, which was interesting and instructive." The *Troy Daily Times*'s article, "The Adirondacks—A Fine Exhibition of Views," said on the same day:

> Without question the exhibition was the most valuable of any of the kind ever given to the public. The enterprise shown by Mr. Stoddard is commendable. Much assistance in preserving the forests cannot be looked for from the members of the assembly who are elected from the Adirondack districts, for they are liable to owe their election to the influence of the lumbermen, and as a matter of course the lumbermen favor the despoiling of the forests. But is it a subject of vital interest, particularly to those that live along the Hudson River, as the cutting down of the trees will surely result in freshets in the spring and fall and a scarcity of water during the summer months.

The same program presented to the state assembly was repeated in many of the larger cities in New York State during the following three months. A report entitled "Adirondack Beauty Seen and Described in Processes of Preservation and Despoliation," in the *Rochester Herald* of April 25, 1892, reads as follows:

> The natural beauty of regions unmarred by the desecrating axe of the lumberman was shown in advantageous contrast to the bare and wasted tracts visited by him. The devastating and fatal effect of denuding the mountain slopes of their protecting growths of trees was also described in a way so lucid as to present in convincing manner to the hearer the necessity and advantage of prompt action by the State in protecting these regions from further spoliation.
>
> As a protective measure the passage of an act restricting the cutting of trees above a certain elevation was suggested. The speaker asserted that action in the matter must come from parties outside the Adirondack region, where the inhabitants are comparatively indifferent, from people anxious to preserve for the State the beauty of its most beautiful section.
>
> "Illustrated Adirondacks" as presented by Mr. Stoddard is an entertainment which cannot be too often heard and seen in vari-

ous parts of the State, entertaining, interesting and instructing as it does all persons who attend it and presenting the facts and actual conditions of a state of affairs whose evils are too little known and whose only remedy is the successful agitation of the public mind by just such methods and means as constitute Mr. Stoddard's "Illustrated Adirondacks."

A writer for the *Glens Falls Daily Times* said on May 10, "If the lecture as delivered last evening, with the accompanying illustrations, could be attended generally throughout the State, it would do more in two months' time to correct the abuses of the Adirondacks than all the surveys and commissions of the past twenty years." Stoddard continued his lecturing after passage of the initial legislation in May 1892, delivering similar messages. Reactions to a lecture Stoddard gave at Chickering Hall in New York City were reported in *New York Times* ("Beauties of the Adirondacks," April 26) as follows:

> While providing entertainment of a most enjoyable nature, Mr. Stoddard's object is also to call attention to the actual conditions, occupancy, and needs of the lovely district of the Upper Hudson.
> "But," Mr. Stoddard said, "it is not alone to kill either game or time that people need care to spend a little while in the Adirondacks. All who love the sublime and majestic in nature or the dainty and delightful scenery of lake and woodland, will find here, within easy reach, a variety which is charming, and a peaceful grandeur which must soothe and elevate their weary minds."
> The despoiling work of man was amply illustrated by views of flooded lands covered with dead timber, and the lecturer's appeal for the preservation of this charming wilderness was powerful.

Stoddard was recognized in an editorial of the *New York Mail and Express* of June 9, 1894, with the following remarks:

> Close upon the heels of Murray, an early publicist of the Adirondacks, came S. R. Stoddard with his camera, his notebook, and his brush, all of which he used continuously for twenty-three years to make the fame of the Adirondack wilderness known to the outside world. Stoddard has done even more than Murray to publish the results of his discoveries, for in guide books, on his maps, in his

marvelous photographs, on the lecture platform, on the screen, in
poetry, and in song, he has for nearly a quarter of a century
preached the Adirondacks and glorified them.

Although much less precise and difficult to estimate, the circu-
lation figures of certain Stoddard publications would indicate a
sense of how many individuals purchased his works. Unfortu-
nately, subscription records as well as information related to the
number of copies printed of the various guidebook series do not
seem to have survived. But no doubt these publications reached
thousands of readers. His stereographs, individual photographs,
souvenir publications of hotels and specific locations, and eventu-
ally postcards and hand-tinted slides were produced and sold in the
thousands. They were marketed in the hotels, on the railroads, and
through photo distribution agencies. In 1896 alone, Stoddard is
said to have sold five thousand slides to the Museum of Natural
History in New York City for resale (DeSormo 1972, 166). Stod-
dard's images and the texts that often accompanied them found
their way to tourists visiting the Adirondacks and lured those con-
sidering travel to the region.

Stoddard's role as a leader in shaping the development of the
Adirondacks in the nineteenth century is twofold: documenting
the wilderness landscape and encouraging tourism with his texts
and images. Oliver Wendell Holmes referred to photography in its
early years as a "mirror with a memory"; so, too, were the images
Stoddard created. His writing and eventually his photographs mir-
rored not only the reality of the wilderness landscape, but also the
collected memory of the places he wrote about and photographed.
His work documented, and through his interpretation shaped, how
thousands of potential visitors thought about and would view the
region. Many of Stoddard's photographic images are artistic in
their own right, but the confluence of his text and images produce
powerful and lasting impressions.

Historically, through the human drive to conquer nature, per-
ceptions changed over time from a fear of the wilderness to an
appreciation of the solitude, beauty, and restorative qualities of

refuge in the wilderness. After the exploration and settling of the American wilderness and the development of urban environments, a transition in thinking about the wilderness occurred. America transformed European traditions from the eighteenth century onward. This was evident in literature and quite demonstrable in the graphic arts. With an expanding middle class, steady business and managerial jobs, and more and easier ways of traveling, the wilderness was discovered and in some ways invented to meet the needs of a changing American society.

Stoddard began his career within this context. His writing and photographs responded to the American desire to retreat from civilization as the nation moved from an agrarian to a technological society. He saw how modern society affected the Adirondack wilderness and controlled the livelihood of many who depended on tourism. He was a central figure in calling attention to the dangers of human progress while also advocating ways to create a balance, a coexistence, between protecting the natural wilderness and allowing people to live in it and make a living from it.

Works by
Seneca Ray Stoddard

Works Cited

Index

Works by Seneca Ray Stoddard

Manuscripts

"Pictured Adirondacks." N.d. Collection of the Chapman Historical
Museum, Glens Falls, N.Y.

Guidebooks

*Ticonderoga: Past and Present. 1873. "Mixed," a Companion to
"Lake George, Illustrated."* Albany, N.Y.: Weed, Parsons & Co.

Lake George; Illustrated. 1873–1914. A Book of To-Day. Glens Falls,
N.Y.: S. R. Stoddard.

The Adirondacks: Illustrated. 1874–1914. Albany, N.Y.: Weed,
Parsons & Co.

*Saratoga Springs and Lake George; Illustrated, Presented to the
Members of the National Division Sons of Temperance of North
America by the Grand Division of Eastern New York at the
Thirty-Seventh Annual Session. 1881.* Saratoga Springs, N.Y.,
June 23.

Photography Books

The Adirondacks. 1878. Glens Falls, N.Y.: Published and copyright-
ed by S. R. Stoddard. Louis Glaser, Leipzig, Witteman Bros. sole
importers, New York.

Lake George. 1883. Glens Falls, N.Y.: published and copyrighted by
S. R. Stoddard. Includes artotype illustrations by Edward Bier-
stadt.

Souvenir of Lake George. 1885. Copyrighted by S. R. Stoddard, 1885.
Title page: "The Horicon Improvement Co., owner and propri-
etor-Lake House, Cable Road, Prospect Mountain, Lake George,
N. Y."

Among the Mountains of the Adirondacks. 1888. Glens Falls, N.Y.:
Copyrighted by S. R. Stoddard. Nims and Knight Publishers,
Troy, N.Y.

Works by Seneca Ray Stoddard

Lake George: Snap Photos from the Steamboat. 1889. Copyrighted
by S. R. Stoddard, published by Nims and Knight, Troy, N.Y.

Camp Life. 1892–94, 1898. No copyright. Twelve photogravures
from original photographs by S. R. Stoddard. Boston: Joseph
Knight Company Publishers. Advertisements appeared in *The
Adirondacks; Illustrated* in 1892 to 1894 and 1898.

Photopanorama of Lake George. 1892. Glens Falls, N.Y.: published
and copyrighted by S. R. Stoddard. Second version dated 1895
with 1892 copyright.

Picturesque American Resorts. Glens Falls, N.Y.: published and
copyrighted by S. R. Stoddard, 1892. Two plates are by W. H.
Jackson.

Souvenirs of the North. 1892, 1894, 1898. Advertised in *The
Adirondacks: Illustrated* as follows: Souvenirs of the North . . .
contain from eighteen to thirty representative views of sections
indicated by their titles . . . *Saratoga, Lake George, Blue Moun-
tain Lake, Raquette Lake, Long Lake, Tupper Lake Region,
Luzerne and Schroon Lake, Wild Lakes of the Adirondacks*
(Ausable Lakes, Tear-of-the-clouds, Avalanche, Colden, Sand-
ford, Henderson, etc.) *Elizabethtown and Keene Valley, North
Elba and Beyond, Lake Placid, The Saranac Lakes, Winter at
Saranac Lake, Glens Falls, Howes Cave.*

Through the Lake Country of the Adirondacks. 1892. Glens Falls,
N.Y.: published and copyrighted by S. R. Stoddard. Advertised in
The Adirondacks: Illustrated.

The Hudson River. 1894, 1898. Glens Falls, N.Y.: published by S.R.
Stoddard, advertised in *The Adirondacks: Illustrated.*

Adirondack Memories. 1898. Glens Falls, N.Y.: published and copy-
righted by S. R. Stoddard.

Bits of Adirondack Life. 1898. Glens Falls, N.Y.: published and copy-
righted by S. R. Stoddard.

Historic Lake Champlain. 1898. Glens Falls, N.Y.: published and
copyrighted by S. R. Stoddard.

Historic Lake Champlain: A Book of Pictures. 1898. Glens Falls,
N.Y.: copyrighted by S. R. Stoddard.

Ausable Chasm. Glens Falls, N.Y.: published and copyrighted by
S. R. Stoddard, 1899.

Works by Seneca Ray Stoddard

Lake George: A Book of Pictures. 1899, 1910. Glens Falls, N.Y.: published and copyrighted by S. R. Stoddard.

Sagamore. 1899. Title page: "Sagamore Park in the Adirondacks summer home of William West Durant from photographs by S. R. Stoddard."

Saranac Lakes Illustrated. 1899. Glens Falls, N.Y.: copyrighted by S. R. Stoddard. Published by Nims and Knight, Troy, N.Y..

Into the Lake Region of the Adirondacks: The Fulton Chain, Raquette Lake, Blue Mountain Lake, Long Lake. 1900. Glens Falls, N.Y.: published and copyrighted by S. R. Stoddard.

Old Times in the Adirondacks. Copyrighted by Maitland De Sormo, Saranac Lake, N.Y., 1971. Based on articles in *Stoddard's Northern Monthly* from December, 1906 through January, 1908 under the title "Old Times in the Adirondacks: Being the Narrative of a Trip into the Wilderness in 1873." Also published in the Glens Falls *Republican* under the title "The Adirondacks" in September and October, 1873.

Panorama of Ausable Chasm. 1907. Glens Falls, N.Y.: published and copyrighted by S. R. Stoddard.

Picturesque Trips Through the Adirondacks in an Automobile. 1915. Glens Falls, N.Y.: copyright by S. R. Stoddard.

Periodicals

Egoland, An Illustrated Magazine of Travel, Truth and Fiction. Proposed quarterly periodical to be published in 1900. In the collection of the Chapman Historical Museum, Glens Falls, N.Y.

Stoddard's Northern Monthly. 1906–8. Published May 1906 to September 1908, twenty-eight issues. Beginning with vol. 2, no. 1 (May, 1907) the title changed to *Stoddard's Northern Monthly: The Pocket Story Book.*

Cited Periodical Articles by Seneca Ray Stoddard

"Landscape and Architectural Photography." 1877. *Philadelphia Photographer* 14, no. 161 (May): 146–48.

"The Head-Waters of the Hudson." 1885. *Outing* 7 (Oct.): 59–63.

"The Rape of the Mountains." 1907. *Stoddard's Northern Monthly* 1, no. 10 (Feb.): 5–9.

Works Cited

Ackerman, James S. 1993. "The Origin of the Picturesque in America." *Occasional Paper, Number One.* Cortland, N.Y.: International Studies Program, State University of New York College at Cortland.

Avery, Kevin. 1986. "The Heart of the Andes Exhibited: Frederic E. Church's Window on the Equatorial World." *American Art Journal* 18:52–72.

Baldwin, Gordon. 1991. *Looking at Photographs: A Guide to Technical Terms.* Malibu, Calif.: J. Paul Getty Museum.

Bartram, William. 1958. *Travels.* Edited by Francis Harper. Naturalist's ed. New Haven: Yale Univ. Press.

Booth, Larry, and Robert A. Weinstein. 1977. *Collection, Use and Care of Historic Photographs.* Nashville, Tenn.: American Association for State and Local History.

Bryant, William Cullen. 1887. "To Cole, the Painter, Departing for Europe." *Poetical Works of William Cullen Bryant Collected and Arranged by the Author.* New York: D. Appleton.

Burkart, A. J., and S. Medlik. 1974. *Tourism: Past, Present, and Future.* London: William Heinemann Ltd.

Burns, Sarah. 1989. *Pastoral Inventions, Rural Life in Nineteenth Century American Art.* Philadelphia: Temple Univ. Press.

Byrd, William, II. 1929. *Histories of the Dividing Line Betwixt Virginia and North Carolina.* Raleigh: North Carolina Historical Commission.

Cadbury, Warder H. 1989. "Introduction and Notes." In *Adventures in the Wilderness.* by William H. H. Murray, edited by William K. Verner. Syracuse: Syracuse Univ. Press.

Carson, Russell M. L. 1928. *Peaks and People of the Adirondacks.* Garden City, N.Y.: Doubleday, Doran.

Cawelti, John. 1976. "Photographing the Western Sublime." *The Documentary Photograph as a Work of Art: American Photographs, 1860–1876.* Chicago: The University of Chicago, The David and Alfred Smart Gallery, Oct. 13–Dec. 12.

Cohen, Eric. 1979. "A Phenomenology of Tourist Experiences." *Sociology* 13 (May) 190–98.

Cole, Thomas. [1838] 1965. "Essay on American Scenery." In *American Art, 1700–1960*, edited by John W. McCoubrey. Sources and Documents in the History of Art Series. Englewood Cliffs, N.J.: Prentice-Hall.

Collingwood, R. G. 1938. *Principles of Art*. Oxford: Clarendon Press.

Colvin, Verplanck. 1880. *Seventh Annual Report of the Topographical Survey of the Adirondack Region of New York to the Year 1879, State of New York*. Albany, N.Y.: Weed Parsons and Company, Printers.

Comstock, Edward, Jr. 1986. "Satire in the Sticks: Humorous Wood Engravings of the Adirondacks." In *Prints and Printmakers of New York State, 1825–1940*, edited by David Tatham. Syracuse: Syracuse Univ. Press.

Crandell, Gina. 1993. *Nature Pictorialized: "The View" in Landscape History*. Baltimore: Johns Hopkins Univ. Press.

Crevecoeur, J. Hector St. John. 1782. *Letters from an American Farmer*. London: Printed for T. Davies.

Crowley, William. 1981–82. *Seneca Ray Stoddard: Adirondack Illustrator*. Rome, N.Y.: The Adirondack Museum and Canterbury Press, June 15–Oct. 15.

DeSormo, Maitland C. 1972. *Seneca Ray Stoddard, Versatile Camera- Artist*. Saranac Lake, N.Y.: Adirondack Yesteryears.

Donaldson, Alfred L. 1921. 2 vols. *A History of the Adirondacks*. New York: The Century Company.

Durand, Asher B. [1855] 1965. "Letters on Landscape Painting: Letter II." In *American Art 1700–1960*, edited by John W. McCoubrey. Sources and Documents in the History of Art Series. Englewood Cliffs, N.J.: Prentice-Hall.

"Editor's Table." 1877. *The Philadelphia Photographer* 14, no. 154 (Aug.): 256.

Ellison, John B. 1957. *Nelson's Complete Concordance of the Revised Standard Version Bible*. New York.

Faxon, C. A. 1873. *Faxon's Illustrated Hand-book of Travel . . .* Boston.

Works Cited

Flexner, James Thomas. 1962. *That Wilder Image: The Painting of America's Native School from Thomas Cole to Winslow Homer*. Boston: Little, Brown.

Foster, Edward Halsey. 1975. *The Civilized Wilderness, Backgrounds to American Romantic Literature, 1817–1860*. New York: The Free Press.

Fuller, John. 1987a. "The Collective Vision and Beyond—Seneca Ray Stoddard's Photography." *History of Photography* 11, no. 3 (July–Sept.): 217–27.

———. 1987b. *Seneca Ray Stoddard in the Adirondacks with Camera*. Syracuse: Robert B. Menschel Photography Gallery, Syracuse Univ., Mar. 8–Apr. 19.

Gilborn, Alice Wolf. 1994. "Picture the Land." *The Adirondack Museum Guide Line*, no. 17 (June).

Gilpin, William. 1798. *Observations in the Western Parts of England, Relative Chiefly to Picturesque Beauty*. London: T. Cadell and W. Davies.

Graham, Frank, Jr. 1978. *The Adirondack Park: A Political History*. New York: Alfred A. Knopf.

Grzesiak, Marion. 1993. *The Crayon and the American Landscape*. Montclair Art Museum, Apr. 25–July 25.

Hammond, Samuel H. 1857. *Wild Northern Scenes; or, Sporting Adventures with Rifle and Rod*. New York: Derby and Jackson.

Harris, Thaddeus Mason. 1805. *The Journal of a Tour into the Territory Northwest of the Allegheny Mountains*. Boston: Manning and Loring.

Headley, Joel T. 1849. *The Adirondack; or, Life in the Woods*. New York: Scribner, Armstrong.

Hochschild, Harold K. 1962a. *Adirondack Railroads: Real and Phantom*. Blue Mountain Lake, N.Y.: The Adirondack Museum.

———. 1962b. *An Adirondack Resort in the Nineteenth Century: Blue Mountain Lake, 1870–1900, Stage Coaches and Luxury Hotels*. Blue Mountain Lake, N.Y.; The Adirondack Museum.

Holt, Lawrence R., and Diane Garey. 1987. *The Adirondack Museum*. Blue Mountain Lake, N.Y.: A Florentine Film Production.

Horwitz, Howard. 1991. *By the Law of Nature: Form and Value in Nineteenth Century America*. New York: Oxford Univ. Press.

Works Cited

Huntington, David. 1966. *The Landscapes of Frederic Edwin Church.* New York: Braziller.

Huth, Hans. 1957. *Nature and the American: Three Centuries of Changing Attitudes.* Berkeley: Univ. of California Press.

Jussim, Estelle, and Elizabeth Lindquist-Cock. 1985. *Landscape as Photograph.* New Haven: Yale Univ. Press.

Kaiser, Harvey H. 1982. *Great Camps of the Adirondacks.* Boston: David R. Godine.

Kaplan, Max. 1960. *Leisure in America: A Social Inquiry.* New York: Wiley.

Keller, Jane Eblen. 1980. *Adirondack Wilderness: A Story of Man and Nature.* Syracuse: Syracuse Univ. Press.

Kolodny, Annette. 1984. *The Land Before Her: Fantasy and Experience of the American Frontiers, 1630–1860.* Chapel Hill: Univ. of North Carolina Press.

Krauss, Rosalind. 1982. "Photography's Discursive Spaces: Landscape/View." *Art Journal* (winter) 311–19.

Lawall, David B. 1971. "Introduction." *A. B. Durand, 1796–1886.* Montclair Art Museum, Oct. 24–Nov. 28.

Leed, Eric J. 1991. *The Mind of the Traveler: From Gilgamesh to Global Tourism.* New York: Basic Books

"Lunar Effects." 1875. *The Philadelphia Photographer* 12, no. 134 (Feb.) 46–47.

Mandel, Patricia C. F. 1990. *Fair Wilderness: American Paintings in the Collection of the Adirondack Museum.* Blue Mountain Lake, N.Y.: The Adirondack Museum.

Marx, Leo. 1964. *The Machine in the Garden: Technology and the Pastoral Ideal in America.* New York: Oxford Univ. Press.

Masten, Arthur H. 1923. *The Story of Adirondac.* New York: Privately printed by Princeton Univ. Press.

McCoubrey, John W., ed. 1965. *American Art, 1700–1960.* Sources and Documents in the History of Art Series. Englewood Cliffs N.J.: Prentice-Hall.

McGrath, Robert L. 1991. "The Space of Morality: Death and Transfiguration in the Adirondacks." *Forever Wild: The Adirondack Experience in Celebration of the Centennial of the Adirondack Park.* Katonah, N.Y.: Katonah Museum of Art.

Works Cited

McMartin, Barbara. 1994. *The Great Forest of the Adirondacks*. Utica, N.Y.: North Country.

Megill, Allen. 1985. *Prophets of Extremity: Nietzsche, Heidegger, Foucault, Derrida*. Berkeley: Univ. of California Press.

Meinig, D. W. 1979. *The Interpretation of Ordinary Landscapes: Geographical Essays*. New York: Oxford Univ. Press.

Mitchell, John. 1992. "Spirits of the Mountains: Seneca Ray Stoddard and Verplanck Colvin Created the Popular Image of an Adirondack Park," *Adirondack Life* 23, no. 2 (Mar.–Apr.).

Murray, William H. H. 1890. *Lake Champlain and Its Shores*. Boston: De Wolfe, Fiske.

Naef, Weston. 1989. "'New Eyes'—Luminism and Photography." in John Wilmerding, *American Light, The Luminist Movement, 1850–1875, Paintings, Drawings, Photographs*. Princeton: Princeton Univ. Press.

Nash, Roderick. 1967. *Wilderness and the American Mind*. New Haven, Conn.: Yale Univ. Press.

Noble, Louis Legrand. 1964. *The Life and Works of Thomas Cole*. Edited by Elliot S. Vesell. Cambridge, Mass.: Belknap Press, Harvard Univ. Press.

Novak, Barbara. 1980. *Nature and Culture: American Landscape and Painting, 1825–1875*. New York: Oxford Univ. Press.

———. 1989. "On Defining Luminism." In *American Light: The Luminist Movement, 1850–1875*, edited by John Wilmerding. Princeton: Princeton Univ. Press.

Oelschlaeger, Max. 1991. *The Idea of Wilderness from Prehistory to the Age of Ecology*. New Haven: Yale Univ. Press.

"Our Picture." 1876. *The Philadelphia Photographer* 13, no. 147 (Mar.): 94.

Pearce, Douglas G., and Richard W. Butler. 1993. *Tourism Research: Critiques and Challenges*. New York: Routledge.

Phillips, Wendell. 1904. "Reminiscences of My Literary and Outdoor Life." *The Independent* 57.

"A Pictorial Record of the Past Made by a Pioneer Photographer— Seneca Ray Stoddard." 1963. *York State Trad* 17, no. 2 (spring): 14–23, 42.

Works Cited

Ralph, Edward. 1976. *Place and Placelessness.* London: Pion.

Roth, Richard Patrick. 1990. "The Adirondack Guide (1820–1919): Hewing Out an American Occupation." Ph.D. diss., Syracuse Univ.

Rush, Benjamin. 1948. *The Autobiography of Benjamin Rush.* Edited by George G. Corner. Princeton: Princeton Univ. Press.

Sandweiss, Martha. 1991. "Undecisive Moments: The Narrative Tradition in Western Photography." *Photography in Nineteenth Century America.* Fort Worth, Tex.: Amon Carter Museum.

Sears, John F. 1989. *Sacred Places: American Tourist Attractions in the Nineteenth Century.* New York: Oxford Univ. Press.

"Seneca Ray Stoddard's Lantern Show." 1992. *Centennial News* (Apr.): 6–8.

Smith, Harold P. 1885. *History of Warren County.* Syracuse, N.Y.: D. Mason and Company.

Snyder, Joel. 1976. "Photographers and Photographs of the Civil War." *The Documentary Photograph as a Work of Art, American Photographs, 1860–1876.* Chicago: Univ. of Chicago, The David and Alfred Smart Gallery, Oct. 13–Dec. 12.

Stillman, William James. [1859] 1983. "Philosopher's Camp." In *The Adirondack Reader,* edited by Paul Jamieson. Glens Falls, N.Y.: The Adirondack Mountain Club.

———. 1901. *The Autobiography of a Journalist.* Boston: Houghton, Mifflin.

Taft, Robert. 1964. *Photography and the American Scene.* New York: Dover.

Talbot, William S. 1969. "American Visions of Wilderness," *The Bulletin of The Cleveland Museum of Art* 56, no. 4, (Apr.): 151–66.

Tatham, David. 1988. "Trapper, Hunter, and Woodsman: Winslow Homer's Adirondack Figures." *American Art Journal* 22, no. 4:41–67.

Terrie, Philip G. 1985. *Forever Wild: Environmental Aesthetics and the Adirondack Forest Preserve.* Philadelphia: Temple Univ. Press.

Thoreau, Henry David. [1864] 1972. *The Maine Woods.* Princeton: Princeton Univ. Press.

Works Cited

"A Tour on Canvass, Beauties of the Adirondacks Shown in the Assembly Chamber." 1892. *Albany Evening Journal*, Feb. 26.

Trachtenberg, Alan. 1989. *Reading American Photographs: Images as History, Mathew Brady to Walker Evans.* New York: Hill and Wang.

Turner, Victor, and Edith Turner. 1978. *Image and Pilgrimage in Christian Culture.* New York: Columbia Univ. Press.

Tylor, Edward B. 1873. *Primitive Culture: Researches into the Development of Mythology, Philosophy, Religion, Language, Art, and Custom.* 2d ed., 2 vols. London: John Murray.

U.S. Bureau of the Census. 1870. *Ninth Census of the United States: 1870, Population, New York State, Warren County, Town of Queensbury.*

Verner, William K. 1971. "Art and the Adirondacks." *The Magazine Antiques* 100, no. 1 (July) 84–92.

Wachusett (pseud.). 1869. "With the Multitudes in the Wilderness." *Boston Daily Advertiser*, July 17.

Weiss, Ila. 1977. *Sanford Robinson Gifford, 1823–1880.* New York: Garland.

Welling, William. 1976. *Collector's Guide to Nineteenth Century Photographs.* New York: Macmillan.

Weston, Harold. 1971. *Freedom in the Wilds: A Saga of the Adirondacks.* St. Huberts, N.Y.: Adirondack Trail Improvement Society.

White, William Chapman. 1985. *Adirondack Country.* Syracuse: Syracuse Univ. Press.

Willis, Nathanial Parker. 1840. *American Scenery; or Land, Lake and River Illustrations of Transatlantic Nature.* 2 vols. London: George Virtue.

Wilmerding, John. 1989. "The Luminist Movement," *American Light: The Luminist Movement, 1850–1875.* Princeton: Princeton Univ. Press.

Index

Page numbers in italics denote illustrations.

Index

Index

Index

Kant, Immanuel: works of, 17
Kaplan, Max, 122
Katahdin, Mt., 28
Keene Valley, 34, 36, 101
Kensett, John Frederick, 24, 32, 35, 109, 111
Kieran, Mary, 68
Kilburn Brothers, 44–45
Kindred Spirits (Durand), 29
King Survey, 38
Kodak, 46
Kolodny, Annette, 126
Krauss, Rosalind, 39–40
Kuo Hsi, 14

Lake George (Kensett), 32
Lake George, Hulett's Landing (Stoddard), 109–10, *111*
Lake George; Illustrated, A Book of To-Day (Stoddard), 45, 51–55, 56–57, 75, 133, 136; page reproductions of, 76, 77, *78, 79*; Stoddard's logo in, 80–81, 83
Lake George: Photographs (Stoddard), 105–6
Lake George and Lake Champlain: A Book of Today (Stoddard), 50–51, 53–55
Lake Ontario and Hudson River Railroad Company, 8
Lake "Tear of the Clouds" (Stoddard), 113, *114*
Lambert, George, 23
Landon Hill, 54
Landscapes, 23, 34, 38, 58, 74, 84, 137; definitions of, 39–40; depiction of endagered, 85, 114–15, luminism and, 24, 31; picturesque beauty, 127–28; panoramic views of, 45–46, 106; romantic descriptions of, 55, 94
Land use, 11, 47, 60–61, 66
Laurentians, 3
Leed, Eric, 122–123

Liberty Enlightening the World (Stoddard), 106
Little Tupper Lake, Adirondacks (Stoddard), 111, *112*
Logo (Stoddard), 80, *81*, 83
Long Lake, 44
Long Lake South, 74, *75*
Lorrain, Claude, 20, 23, 31
Lower Ausable Pond (Stoddard), 72, 74
Lower Saranac Lake, 58–59
Lumber industry, 7, 9, 10, 60–61, 62, 66, 127, 139–40; charcoal manufacturing in, 116–17
Luminism, 24, 33; elements of, 31, 32; in photography, 40–41, 109–11
Lunar effect, 108
"Lunar Effects," 132
Lundquist-Cock, Elizabeth, 39
Luzerne, 50
Luzerne Falls, 116

Macomb, Alexander, 7
Mandel, Patricia, 27, 33, 34
Manheim and Salisbury Railroad Company, 8
Map of the Adirondacks, 51
Marcy, Mount, 4, 62, 101, 113
Marx, Leo, 23–24
McEntee, Jervis, 34
McGrath, Robert, 25
Meinig, D. W., 39
Michigan Territory, 14
Mining, 9
Mohawk Valley, 6
Montreal, 5
Moody, Mart, 101
Moore, N. A., 35
Moreau, 43
Morrison lens, 87
Murray, William H. H., 21, 68, 97, 140; *Adventures in the Wilderness; or Camp-Life in the*